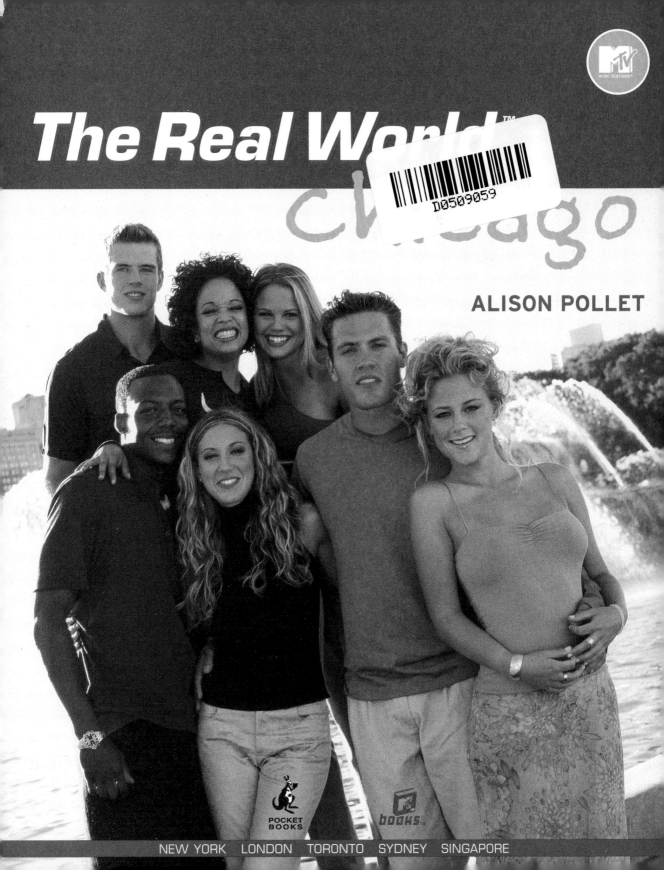

The Real World™
chicago

ALISON POLLET

POCKET BOOKS

MTV books™

NEW YORK LONDON TORONTO SYDNEY SINGAPORE

SPECIAL THANKS TO:

Scott Freeman, Vice President, Creative Affairs for Bunim/Murray Productions

The cast of *The Real World—Chicago*: Cara, Keri, Aneesa, Theo, Kyle, Tonya, and Chris

Amanda Ayers, Allison Bennett, Brian Blatz, Liz Brooks, Mary-Ellis Bunim, Elda Collier, Joyce Corrington, Anthony Dominici, Michelle Dorn, Ken Freda, Michelle Gurney, Darryl Hicks, Jacob Hoye, Kenny Hull, Justin, Andrea Labate-Glanz, Suzanne Leichter, Preston Kevin, Lewis, Jon Murray, Donna O'Neill, Lisa Silfen, Robin Silverman, Donald Silvey, Liate Stehlik, Van Toffler, Elizabeth Vago

PHOTOS PROVIDED BY:

Rudy Archuleta, Allison Bennett, Anthony Dominici, Bunim/Murray Productions, and the cast and crew of *The Real World—Chicago*

An *Original* Publication of MTV Books/Pocket Books

POCKET BOOKS, a division of Simon & Schuster, Inc.
1230 Avenue of the Americas, New York, NY 10020

contents

CHICAGO

"THE REAL WORLD"

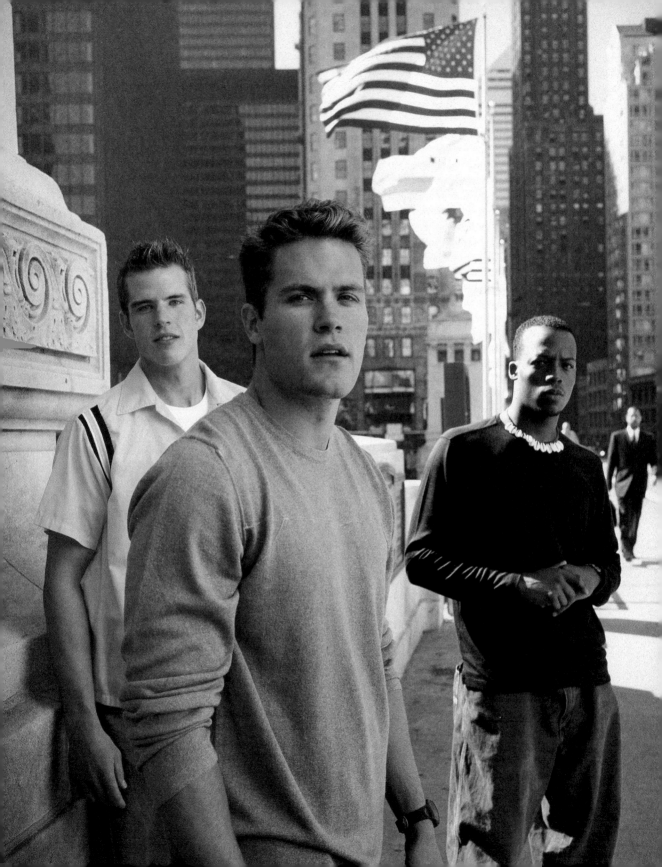

Introduction

Q & A with Mary-Ellis Bunim and Jonathan Murray

Q: Why did Chicago work so well? What makes a great *Real World* show? What do you consider to be the touchstones for a great season?

Jonathan Murray: I think the Chicago season worked great first and foremost because of the cast. They define a season. If you don't have a good cast, even if you have the greatest loft in the world, you're not going to have a good television show. I think we hit gold with the cast—they were sexy, provocative, entertaining; they were just a delight to watch. Our first episode, particularly, you had Aneesa having fun with Theo and Theo having fun with Aneesa. I think a lot of people were really touched by Chris and his nervousness about coming out to his roommates. I think people were certainly teased by what potential there might be for a possible romance between Kyle and Keri.

Q: Cast members are always bemoaning the fact that only a fraction of their lives is shown when the show is put together. How different is the *Real World* that viewers see from the dailies that you see? Are cast members really being shortchanged?

Mary-Ellis Bunim: Well, I think the *Real World* the viewers are seeing is much more entertaining, certainly more than the real world as it exists in most of our lives. Clearly we're here to tell stories that are entertaining to the audience, we're not here to bore. Like a lot of people's lives, the cast members on *The Real World* can be dull at times. We don't need to watch them eating a baloney sandwich or reading a book. We're focusing on stories. So, in that way, it's not fully representative of their lives, but it's representative of the meaningful parts of what happened in Chicago. Generally, we do tend to focus more on conflict because that conflict often leads to growth on the part of a cast member. Overall, if you look at all twenty-two episodes, I think they're pretty representative of the cast members.

Jonathan Murray: I think it's always hard to watch yourself. I know that I'd hate it if someone always filmed me, because I probably say things that are not always appropriate and I wouldn't want that shown to anybody.

Q: We've seen how the casting process works through casting specials. But what we don't know is how a show gets made. Take us through the process of making an episode of *The Real World.*

Mary-Ellis Bunim: Well, it begins with the producers and directors and crew in the field as they are documenting each day in the lives of these cast members. They are

watching to see if the events are more than mundane, if they have significance. So, the directors—and we have five of them who lead the crews—are focusing the cameras on any situations that are meaningful. Tonya talking on the phone for an hour and a half to her boyfriend is not necessarily interesting, unless Aneesa wants to use the phone and is pacing back and forth and you can just tell that there's gonna be a fight over that phone. Or Theo hangs up the phone because he gets tired of waiting for Tonya. So, it begins with the directors in the field deciding where to put the cameras because we only have one camera, maybe two, on per shift.

Jonathan Murray: We have seven cast members, so if Chris and Tonya are going off to the gym and Theo and some girl are going on a date, we'll go with Theo and the date, thinking that's a better story. If, say, Chris and Tonya haven't been speaking to each other and this is the first time they're going to do something together, then we might go with them because that potentially might be the next step in their story with each other. So it begins with the directors trying to ascertain what's important to shoot. They write up director's notes about what they've shot that day and that comes back to L.A., to our story department and the rest of us. Then our loggers watch all of the material, and our story department watches it to put together each of the episodes, figuring out what the "A" and "B" story of an episode is going to be. The story department pitches out each episode in a two-page outline to the rest of us and we give our thoughts. Based on those notes, they write a twelve- to four-teen-page script. The script serves as a guide to the editor on how to put the show together—what the tone of it is and what each scene is about. Then it goes to the editor and they spend about four and a

half weeks getting together a first cut of the episode. All of us then get a copy of that and look at it, and give notes to the editor on what we think is working and what's not. Then, when we're satisfied with it, it goes to MTV and then they give their thoughts on the episode, and we make any changes they request. Then the episode is onlined and sweetened for air. All in all, from outline to online, each script takes ten weeks to produce.

Q: During casting, had you made any predictions as to what would happen among the cast?

Jonathan Murray: Basically, we've learned not to make predictions because we're never very good at it. We've come to the realization that if we just put seven great people in the house, interesting things will happen. If you look at the first show, we had Kyle and Cara at the train station together, which might indicate that some of us here thought maybe there might be some sparks between them. As viewers know, ultimately, I think Kyle and Keri were more attracted to each other than Kyle and Cara were. If you want to take from that that maybe we thought there would be some sparks, then maybe you would be correct. Generally, we just find that it's best to pick great people and then let the chips fall where they may.

Q: Who surprised you?

Mary-Ellis Bunim: Well, Tonya was a bit of a surprise because during casting she had broken up with her boyfriend. So it was a bit of a surprise when she showed up seemingly headed toward marriage with him. That gave us a whole story line. Also her illness was a complete surprise; that didn't come up in the casting process. I think we were also surprised that Kyle, even though he had broken up with

his girlfriend, Nicole, was still feeling a responsibility toward her in terms of his actions, that he didn't feel comfortable dating other women because he was concerned that it would somehow be rude to her. That surprised us a bit.

Q: Who grew or changed the most throughout the season?

Jonathan Murray: I think that probably Theo grew a lot. He had his first real gay friends, so I think that gay people now have faces to him. That doesn't necessarily mean that he's changed his views toward homosexuality as they relate to the teachings of his church.

I also think that Aneesa grew up a little bit. She had grown up in a situation where her mom had, to some extent, spoiled her. She had to sort of take care of herself a bit while she was in Chicago, which I think was good for her.

Q: This is the third time you've had a very ill cast member. As producers, what are your responsibilities?

Mary-Ellis Bunim: It's always difficult when a cast member becomes ill, because on the one side we want to do everything that we can for them, while on the other side we're supposed to be documenting their lives and it's a better and more relatable story if we don't interfere, letting them deal with their lives. I think in the case with Tonya it was a good decision because she had to struggle to find care and, ultimately, she had to fill out the forms to get the financial donation to pay for her illness. I think that's a much more relatable story for our audience than if we had simply solved all of her problems.

Q: What are your impressions of the cast since the show finished taping? Is there a difference?

Jonathan Murray: Boy, I was lucky enough to have dinner with them not long ago and they're a lot of fun. They really seem to have gotten a lot out of the experience of being on *The Real World*, they seem to have gotten over any petty problems with one another. I know you did interviews right at the end of *Real World–Chicago* and I know they were still a little angry at each other, feeling some of the insults and some of the things that happen when you live in close quarters for five months. But two months later, that was all gone and basically, they remember all of the good times. They care about one another and really take care of one another.

Q: What are your favorite *Real World* moments—this season and all seasons?

Jonathan Murray: I love the moment in the first episode where Aneesa decides to go into the shower with Theo and Cara tells her not do it; she does it anyway and Cara makes this funny face. That's a great moment, perfect timing. I think the September 11 episode that we have is pretty amazing. We just kept our cameras rolling during that period of time and what we captured I think is very representative of what a lot of young people were feeling: that sense of helplessness and sudden realization that just because you're in America doesn't mean that you're protected from all of the awful things that happen in this world. You really see this realization on the part of our cast members, and perhaps their generation, that their innocence is gone and they're face-to-face with their own mortality.

Q: How did September 11 affect filming? Did reality conflict with reality programming?

Mary-Ellis Bunim: No, the only change we made was that we gave the cast a TV set for a couple of days so that they could see what was going on. But no, I think the interesting things is, for instance, Aneesa and Tonya, who were having a lot of disagreements about the phone, suddenly realized how petty those were and suddenly came together and overcame those difficulties because they realized there were more important things to be thinking about.

Aneesa: If I have any message for the readers of this book and the people who watch *The Real World*, it's this: Don't let anyone tell you you're not amazing. If you love yourself, everyone else will too. Just be yourself. Other people matter, but you're the only one who has to live with you for the rest of your life.

Cara: If I have a message to people reading this, it's this: Try your damnedest to be happy. Seek confidence, but work harder at being selfless. There are more important people in the world than yourself.

the

cast

The biggest lesson I learned: How to live out of my comfort zone. I'm ten times as independent as I used to be.

Keri

Keri: When I saw the first episode, I thought I'd be really devastated. But honestly, I thought it was funny. The whole time I was thinking, *I'm such a dork.* Why did these people want to follow me around?

I think we have the potential of being a really good cast. They could make this show really funny. We didn't have any big deep-seated issues. OK, maybe Tonya and Theo did. But except for them, we had sibling-type fights. Basically, we were all cool. What I want is for them to show the good stuff. Show that we got along and had fun! Come on! Show Theo singing church songs while playing Jenga! Show us cracking endless dirty jokes. Show the good times.

In the *Real World* house, there's no music and there's no TV. I read an awful lot, but there's really no relief. I had to retreat into my own mental space. People tell me I live in my own world. I guess I do, a little bit. If something's really boring, I'll just trail off. Here's an example: Tonya and I went to the movies at a place in the suburbs. We called the house and no one wanted to give us a ride home, so we had to take the El (subway) back. She got really pissed that no one would come and get us. She got all mean toward the people we lived with, talking crap. Well, I just retreated into my own world. I started quoting *Monty Python and the Holy Grail* in my head. I think I might have even said some lines out loud. I just couldn't handle listening to her anymore. All she cared about was being late to call Justin. She was going on and on. Who cares?

When people were really annoying me, I'd have to get out of the house for a bit. I'd go down to Michigan Avenue and shop. The cameras never came with me when I did stuff like that. We did a lot of shopping. My credit card's never going to recover. The stripe's probably totally worn out. The guy in French Connection knew me. I'd be in there buying T-shirts and sweaters weekly. My mom would get my bills from Neiman Marcus, and I'd have to be like, "Thank you, thank you, Mommy." In fact, my favorite day was when I went shopping with Chris and Theo. We went to a bunch of stores. I walked into their dressing room just as Chris was asking Theo how his a** looked in jeans. Theo was speechless. I was laughing my a** off.

I can't believe I got to live with such awesome people. With the exception of maybe Kyle, I think I'll keep in touch with everyone. Cara and Aneesa and I will talk weekly. I very rarely bond with girls; they're not as easy as guys because they're more complex. But we girls had so much fun. We had some really fun, out-there times.

Personally, the only thing I didn't want to do was fully get it on on-camera. I have a 9-year-old sister and I didn't want her to see that. It's not like I was stopping myself from being a total slut; it's just that I checked my sexual behavior. I guess it's a good thing I didn't meet a guy I really wanted to sleep with in Chicago. There were a lot of guys out there who wanted to have something to do with *The Real World.* Guys would call Cara, and if she'd say no, they'd be like, "Can I talk to Keri?" Or vice versa.

I feel as though everyone had something they wanted to hide from the public: Tonya had her wild, dirty side that she wanted to keep from Justin's family; Cara had a relationship back home—not Jared—that she wanted to keep to herself; Kyle had Nicole to protect. People might judge us for holding stuff back. But everyone has secrets.

I can't believe I got to live with such awesome people.

I actually called Kyle out for all his secrets. The last couple of weeks, things got boring. The show was winding down and we knew we were leaving; it felt like time to go and it just got dull. I picked a fight with Kyle, mainly because I could. I accused Kyle of stuff I regret, hiding things from the camera and playing to them. I guess I think that if you're lucky enough to get on the show, then you should experience the entire emotional range. I don't think Kyle did that.

We saw *The Real World–New York* a couple of times during filming. We watched it in St. Louis at Cara's house. And Kyle and I watched it at his friend Butler's house. We saw the one when they go to Morocco and meet up with the *Road Rules* group. *We were like, What the hell? We went nowhere! We didn't get to do a Challenge. The seven of us would have beaten a** at something like that. We were shafted!*

I think we regressed a bit, living in the house. It was like being back in high school and talking behind people's backs all the time. But I think we overcame that and really grew. I know I changed a lot. I learned how to live without my family. Not that I was crazily codependent with them, but I'd never been separated from them before.

I'm going back to school now. I have a year left until I graduate. I could graduate in the spring, but I'm changing to a double major: psychology and criminal justice. Did I learn anything about psychology living in the house? No, not really. I prefer abnormal psychology, and my roommates don't fit into that category—at least, I don't think so.

SCARED I'LL BE SEEN AS:
I wouldn't want to be known as a dumb-a**. I guess I'm scared the only story people will see is me and Kyle. Oh, forget it; I don't care what people think of me. My family and friends know me. I'm not worried about anything. I went to Chicago to experience it and that's what I did.

WANNA BE SEEN AS:
Funny, intelligent, not a know-it-all, but someone who knows what she's talking about. Someone who has fun, but experiences where she is at the time.

Cast Speak

Aneesa: My love, my Keri. She said if she were ever gay, I'd be the first person she'd come to. That's flattering. Seriously, though, we have a friendship I wouldn't want to mess up. I think she's a wonderful person. At times, I think she wasn't being herself. We were all nervous about how we presented ourselves, and I think she was the most nervous. Keri is very determined, so I think she'll do whatever she wants to do in life. She's an individual. ***Will we keep in touch?*** We will talk all the time.

Tonya: Of all the women in the house, I relate most to Keri's intensity and drive. She's spontaneous and competitive and she'll try anything. That could also be a bad thing. Keri was always the funny girl who had to crack the most jokes. She was always in competition with everyone to be the funniest. I admired Keri for loving her family so much. She had a strong connection to them and needed to talk to them every day. I loved how in love with her family she was. ***Will we keep in touch?*** I hope so. Keri and I could be really close. My defense mechanisms have kept me away from that. Her family adores me and I could be part of it.

Cara: Keri's so fun and adorable and sweet. We had a great rapport. We liked to drink together and eat and talk. She became a really good girlfriend. I think she's really smart, and I like that she can be moody and bitchy. I didn't realize this until a good two months into it, but Keri's actually quite insecure. Tonya pointed that out to me. I thought Keri—a tough-talking bartender, Daddy's and Mommy's girl, who could get every guy she wanted—would be really secure. That isn't the case. **Will we keep in touch?** Yes, all the time. I adore Keri and her family.

Chris: Keri had a difficult time adjusting to Chicago, but as soon as she let down that defensive shell, things got better. She acts all high and mighty, but she's full of charm. She's highly opinionated. She's all "Love it or leave it, I am what I am." I love that about her. **Will we keep in touch?** Definitely. We'll talk on the phone and e-mail.

Theo: I didn't know women could be so strong and so independent. Keri was always, "I don't need your a** to help me." There were conflicts because, in my view, the man needs to be responsible. We know she could have fixed the car tire faster than we could, but I gotta do it. To me, Keri is a great person. To chill with her, you gotta be special. **Will we keep in touch?** Definitely. I'm going to New Orleans for Mardi Gras.

Kyle: Keri has an awesome, free-spirited attitude. She's also very maternal. On the downside, she's a control freak who won't admit when she's wrong and doesn't like it when she doesn't get what she wants. **Will we keep in touch?** Maybe occasionally. Right now, she's the last person I want to talk to. She used to always ask me if we would keep in touch. I'd tell her I didn't know. I still don't know.

Crew Speak

Anthony Dominici, producer: Keri is stoic and doesn't play her emotions on her sleeve. She was very unhappy at first. She'd moved away from home and was in a world she didn't know. Everyone labeled Tonya the small-town girl in the big city, but Keri really fit that bill as well. She related to Tonya more than she let on. But time passed, and she settled in and decided to have a good time. When the job changed from lifeguarding, I think she got happier. When Keri's at her best, she's funny, flirty, really independent. When she's comfortable, she opens up more. She does too good a job at hiding who she is.

Jon Murray, creator: I think moving to Chicago and living in the *Real World* house was a bigger challenge than Keri thought it would be. She has so much support back in New Orleans and in Chicago she had only her new roommates. Obviously, Keri's beauty was the first thing I noticed about her, but it was her uncompromising honesty that made me want her as part of the *Real World* cast. Now, watching the completed episodes, I think it is that honesty that makes her so compelling.

Mary-Ellis Bunim, creator: Keri, in spite of her strong exterior and clear independence, is a vulnerable young woman who has just begun to experience real challenges in life. Hopefully she won't consider watching herself on TV one of the bigger challenges. I think many girls will relate to how she fell for someone who was emotionally unavailable.

If I learned something in Chicago, it's this: Make sure what you say is gonna make sense before you say it.

Theo

Theo: How I'm feeling right now is weird. I loved the cameras on me. The attention we got when going out was like no other. When it came to people staring, I loved it. I was into the whole thing—the lights, the mikes, living with strangers. It was all good. We had some pretty dynamic relationships. I'm gonna be crying like a bitch when I no longer live here.

There was only one time when I hated the camera and that was when I was ironing. For some reason they were always on me the second I ironed. I was like, What? You never seen a black man iron?

Coming into this, I knew I'd be the only African-American in the house. I knew I'd be the only brother, but maybe there'd be another black girl. Aneesa's a mix, but she still felt like my sister. For any black male on this show, it's an awkward position. From jump street, the black man got the bad vibe. I'm not here to represent all black men in America. I'm here to represent myself. Love me for me and hate me for me—that's your decision.

The Real World was a way for me to break out from my dad's shadow. My whole life, I have had to deal with people thinking I shouldn't do stuff because I'm the pastor's son. It's been a blast being my dad's son, but I'm growing up and I want to be known for myself. If there's any reason I did this, it's to become the man that I am. Being a preacher is not my interest; being an architect or doing whatever comes out of this show is.

A lot of my church is going to judge me. I love them, but they don't deserve to judge me. They try to act like they're holier than holy. Ain't nobody praying as much as they say they do. But there are going to be some shocks for them. They know me as

the pastor's son and the big brother to every single kid in the congregation. They don't know me as Theo in a club, Theo with women. They're either gonna accept me or hate me and I don't give a damn. I will always have unconditional love for them. I know my parents will never disown me. They'll always have love for me. The people who genuinely love me will still love me.

My parents and I have an awesome relationship. My parents missed the crap out of me when I was in Chicago. It made me feel good. My mother tells me I'm the best thing that ever happened in their lives. They were trying to have a kid for a long time, and I'm what they prayed for. In my whole life, my mom and I have had just two arguments. I hope viewers see how into my family I am. I also want them to see me as the only one who never missed a day of work, even though I was the one up all night. I want to be seen as someone who makes people feel good, makes people smile. People need laughter.

Do I want to be seen as a player? I don't consider myself a player. A player gets something out of a situation with a girl, any girl. Yes, I like to talk to different women. When I'm in a relationship, I'm the best boyfriend you could have. I've never cheated on a girl. When I'm single, I try not to hurt people. I try to be safe. But I'm young, and I wanna have a good time.

One thing I learned here is that I can really lash out at people when I'm angry. I can really get in people's faces. When I'm in a heated situation, I don't think as much as I should. I should think more when I say stuff. I just want to get it all out. But that sometimes backfires when you're dealing with someone like Tonya. The truth is,

I'm gonna be crying like a bitch when I no longer live here.

Not scared.

A young man who's enjoying his life and trying to take advantage of any situation put in front of him. I want them to see me as a party animal.

Tonya's the kind of person you have to force yourself to like, and I don't think many of us like her. Actually, I don't think any of us like her. We have love for her, but we don't like her. The Lord wants you to have love for every human being, goodwill. I have that for her. That's not the same as liking someone.

I'm proud to have been in my cast. And I'm proud to be part of The Real World. It's something I've wanted my whole life. Would I have liked to be in the New York cast with all those other black people? Well, I do think Coral was sexy. I would have liked to be in the house with her little attitude and played with her. Me and Malik would have run that house, it would have been ridiculous. I would love to meet them all, especially Nicole and Coral. Those are some beautiful black women, damn. I was a little heated I wasn't on that one, but it's all good.

Cast Speak

Kyle: Being on The Real World was a dream come true for Theo. He'd be so up-front about the fact that The Real World was his favorite show. I think he had more fun than anybody. He went out by himself every night. I have love for Theo and he has love for me. He's a family-oriented person, and I appreciate that. **Will we keep in touch?** Absolutely. He's gonna keep up. He's not going to fall out of touch.

Tonya: I don't have anything to say about Theo except he's young and he has a lot to learn. If you don't cross him, he can be a great guy. He's from a good family and should behave better than he does. I didn't like Theo from the beginning. He's pretty much a jerk in my book. **Will we keep in touch?** No, I don't think so.

Aneesa: Theo's wonderful. He's my man, my soul, my everything. I love him so much. I don't think I would have made it without him. He understood me when others didn't and was there for me when others weren't. I think he's the person I'm closest to in the house. Our relationship was solid from the beginning. Theo is determined folk. He amazes me with all his plans for the future. I trust that whatever he does, he'll be amazing. **Will we keep in touch?** We'll probably talk once a week and page each other

900 times. I love him so much, I can't imagine my life without him.

Cara: Theo can be such a womanizer, then at the same time be the most charming gentleman ever. He hugs people instead of shaking their hands. My parents loved him and he was so cute with my sister. It surprises me that he's an only child, because he's so unselfish. Theo and I had a great relationship. We were so candid and honest with each other. In the beginning, we'd joke about how we all got along too well. I took some of his humor back home with me and I think he took some of mine with him. *Will we keep in touch?* I hope so.

Keri: Theo was in it to have a good time, and he stuck to it. He got there on cloud nine and left there on cloud nine. He's funny as hell. Being a woman, you could not open a door in that guy's presence. He's super chivalrous. I called him from the coffee shop across the street because I didn't have an umbrella and I had my mic on. He came to walk me across the street. He's so successful—he's got so much passion, he's going to go places. He really is. *Will we keep in touch?* Definitely. I talked to him three times in the first two weeks after being home.

Chris: Theo is the most beautiful, sweet, loving person. I think he's really brilliant about art and architecture. He's a total sweetheart; against all odds, we became friends. Theo will never be comfortable with a gay lifestyle for himself, but he was OK for me to have one. *Will we keep in touch?* I know we will.

Crew Speak

Anthony Dominici: Love me some Theo. He's so funny. He's an all-around good guy. He gave us so much of his personality. He and Aneesa both said what they were thinking point blank. You've got to respect that. It was difficult to see Theo get into trouble with his mouth when he so bravely laid it on the line. I'd cringe when he said things I thought he'd regret later. Theo's a talented kid. He can accomplish anything. He was raised right and he had some great parents. He spent a lot of time out here playing, now it's time to put his nose to the grindstone.

Jon Murray: We got to see many sides of Theo in Chicago. We saw the party guy and the guy who's committed to being a role model for young people. What we didn't get to see is the romantic side of Theo. I don't know if the right girl just didn't come along or whether Theo made a conscious effort to avoid serious attachment, but it's a big disappointment for me that we didn't see him in a serious romantic relationship.

Mary-Ellis Bunim: How great was it that Theo and Chris became friends? That's what is so awesome about this show: people of different backgrounds can transcend their prejudices and share their experiences. I loved watching those two guys bond.

13

The biggest lesson I learned: I don't have to love everyone and everyone doesn't have to love me. Grasping the second part is harder.

Cara

Cara: How did I feel when the cameras were turned off? Overwhelmed, relieved, and terrified. I don't know if I'm ready for the country to see me.

I watched the first two episodes and cried my eyes out. I couldn't sleep at all, I was analyzing every little detail. One of my biggest insecurities is that people don't like me. I know, I know, then why did I do a show like this if that's my problem? Clearly, I'm going to get critiqued. Viewers are going to be like, She's not that hot! Look at her hair! She is such a bitch! That stuff scares me. I like everyone to think I'm sweet and pretty and smart!

My mom said this, and I think it's true: I took the biggest risk I could possibly take by being on *The Real World*. I could have moved to Beijing for a year and felt more comfortable. I never want to say anything to upset people, and here I am going on a show where you have to be honest...and that means not always being nice.

But I really try to see the best in people. I don't know where that comes from, if it's some hokey Midwest thing I developed or something. You know that Whitney Houston song "The Greatest Love of All"? It's saying that the greatest love of all is to love yourself. Well, I don't buy it. It's so much cooler to love other people. It may sound dumb but I think it's cool to be nice. I appreciate kindness.

But yes, I also think it's healthy and real to talk crap about people. When I watch the shows, I expect to hear bad stuff about me. I expect to have my feelings hurt. I have dreams where viewers write me and tell me to get plastic surgery.

If I'm nervous about anything, aside from coming off as promiscuous, it's being portrayed as the rich princess from privilege. Going in, I was really nervous about that. But I have to say that for the most part, all of us come from entitlement. Everyone had cell phones, everyone had cars, everyone had whatever they wanted. Even Tonya goes to college and has nice clothes. Even if I am privileged, I would never act the spoiled, obnoxious rich girl. I've pretty much grown up with what I wanted, yes. I've always had nice cars bought by my dad. But I'm generous with money. One of the coolest things Tonya said to me was that I changed her opinion of wealthy people. She told me she thought she'd hate rich kids. But I surprised her.

There was definitely some animosity between me and Aneesa about money. She was mad she didn't have her mom's credit card. She was really bad with money. It was frustrating. We'd all get the same paycheck, and I'd have money at the end of the week and she wouldn't. She would take her paycheck and buy two pairs of Pumas from Urban Outfitters. She's more spoiled than I am. And I think Keri was more spoiled than I am. She gets whatever she wants when she wants it. Apparently, though, she pays her own bills—something she liked to remind us of constantly.

Little things aside, our house was incredibly tight. If it was divided at all, it was all of us and Tonya and Chris on the outskirts. Chris was always working out and Tonya was always on the phone to Justin. I can count on one finger the times she went out with us. She didn't even go to the wrap party. Well, she went, but just for two hours. How lame is that? For months

> **It may sound dumb but I think it's cool to be nice.**

Backstabbing and promiscuous. I'm scared people will see me being too flirty, talking too crassly.

WANNA BE SEEN AS:
In my ideal world, I'd be seen as funny, sexy, pretty, talented, smart, warm, witty, and as a caretaker.

we'd been looking forward to talking to the crew. She probably wanted to talk on the phone to Justin and rent a porno. She doesn't care. She is not going to miss us. She just wants to marry Justin and get on with her life.

It represents a lot to me that Tonya missed the wrap party and Tonya and Chris both missed my singing at the Daily Grind. That was one of our final nights and we were all crying and hugging, and surprise surprise, neither of them was there.

I know how lame it is that I'm scared to confront people but have no problem talking behind their backs. The truth is, while it's difficult to talk about my roommates, it's even harder to talk about myself. I don't want to sound hypocritical and I don't want to sound selfish.

Before we left for the airport, I told my roommates I adored them, but there would be times when they heard stuff they didn't like coming from my mouth. It won't mean we don't still love each other. It's like a family.

Cast Speak

Tonya: Cara is very precious to me. When I first met her, I thought Oh, s**t. My friends from home were like, "You know you're going to live with some prissy little bitch whose dad is a doctor." I thought that would be Cara. It turns out it's not. We're equally as caring and loving and yet we come from opposite sides of the tracks. We had a lot of late-night conversations about life. I was like, "You're always the first person to crack a joke, but will I ever see the real Cara?" She opened up to me about taking Prozac and still feeling pain. There are things that I wouldn't let Cara get away with that I'd put up with from someone else, say Aneesa. There were times I made her cry when I called her out for talking behind people's backs and not telling them crap to their faces. I was like, "Take a stand. If you don't, you're going to take a fall." **Will we keep in touch?** Yeah, we will, definitely.

Kyle: Cara was my absolute favorite roommate. We had such chemistry the second we met at the train station. It's so satisfying for me to think that she and I have nothing but good happy memories together. I wish we could have done more stuff one-on-one. I can be a pretty s**t-talking cynical guy and I found a partner for that with Cara. We developed a really cool brother-sister relationship. Cara and I had a real connection and I know that she would say I was her favorite roommate too. **Will we keep in touch?** Without a doubt.

Keri: Cara's awesome. My first impression was that she might be a hippie—she had that little thing in her hair. I knew I was going to like her. She wants her own sitcom and I kind of feel like *The Real World* was that for her. My family loves her and I love her parents. We became really close, and I think we'll stay that way. ***Will we keep in touch?*** Cara and I are going to talk either every week or not for months—but when we do talk it'll be like we were with each other the day before. I love L.A. and can't wait to visit her.

Aneesa: I love Cara. I love her. I think she came a long way—from being shy and trying not to hurt people's feelings to being able to stick up for herself. From the door, Theo and I were telling her to stick up for herself. With the relationship Cara and I have, we'll be friends for life. Our personalities are so similar but our lives are so different. ***Will we keep in touch?*** Of course.

Theo: Cara's grown in the sense that when we first got to Chicago, she wouldn't tell people if they pissed her off. She didn't give a damn anymore at the end. Now she's not afraid to show anything. She and I never really changed our relationship when the camera was on or off, we were always good friends. We never got into an argument, we always respected each other. She's a beautiful person with a personality like no other. I love her sarcasm and I think I've picked up some of it. ***Will we keep in touch?*** Definitely. Hopefully at least once a week. We're going to keep up a good relationship.

Chris: Cara is very gentle and kind. I think she had a lot of fun in Chicago. She's funny and full of life. I do think it would be good if she could get out of her parents' shadow, though. She needs to learn how to be independent. ***Will we keep in touch?*** Yes. She's the kind of person with whom it will always be the same the instant we talk.

Crew Speak

Anthony Dominici: In Chicago, Cara dealt with becoming a strong, independent woman and learning that she's the one in control of her happiness. When she got here, her big mantra was: "It's OK, it's OK, it's OK." She tends to gloss over dramatic things in her life for the sake of letting things slide by. She hates confrontation. To see her stand up for herself was very powerful. She did that with Tonya. She'd spent so much time taking care of Tonya and then Tonya turned on her—with the *Bloody Mary* script and by not seeing her sing at the Daily Grind. Cara's going to L.A. to see what her prospects in the entertainment world are. In order to be an actor or a director, Cara's going to need to become more empowered.

Jon Murray: Listening to Cara's funny one-liners and watching her comedic facial reactions to different situations has convinced me that this cast member, more than most, could have a future as a comedic actress. If she goes for it and is willing to really put the work in, I think she could end up on a sitcom.

Mary-Ellis Bunim: If we had had 10 more episodes, we may have seen more of Cara's talent for singing, acting, directing, and her ability to reach out with genuine friendship.

The Real World was the beginning of my real world.

Kyle

Kyle: Moving out of the house was a whirlwind, like being in a dreamland. Everyone reacted pretty dramatically to moving out, and then when we saw a screening of the first episode—well, some people had some sleepless nights. It's just such an emotional thing. Cara cried for hours.

Seeing yourself on TV for the first time is like meeting a sibling you didn't know you had. It's not necessarily a bad thing, but it's very emotional. I almost lost it when they showed the picture of Nicole. She's very private and precious to me. We have this sacred relationship and then to see it as part of a TV show—you can't prepare yourself for how that feels.

I don't know what I'm going to do next. It's really hard for me to make life decisions. I'm the only roommate of the seven who doesn't have anything to go back to. I don't know what effects—if any—the show is going to have on my life. I'm very interested in any industry opportunities. I think I thrive in an atmosphere with cameras. I like the limelight and I'm comfortable with it. I was the running back on the Princeton football team. That was the glamour position.

You don't necessarily have to like the limelight to be on *The Real World,* but you have to be comfortable with it. Aneesa would always be yelling at the cameras to get away from her, she didn't want to be filmed. I'd be thinking, *What did she think this was going to be like?* That's what we're here for! I was very professional with regard to production. I complied with the rules. I respected production's jobs. When people in the house bitched about having to wait for the camera crews or about the job we were given, I literally didn't get it.

Keri probably bitched more than anybody else. Then Aneesa, then Theo. They didn't like our jobs. I didn't either, but it's like, *C'mon, man, put up with it, you're on* The Real World. Theo was the huge fan of the show. His being on the show was like me playing for the Chicago Bears. Be grateful.

All the girls except Tonya would line-cross with the crew. Aneesa would get up in their ears and whisper stuff to them. OK, there were a few times I messed with production. I went to pay phones to talk to Nicole. All I wanted was a speck of privacy. I didn't like sneaking around. And, anyway, it wasn't worth it. I'd give them the slip, but then I'd be rushed and nervous the whole time Nicole and I were talking. It was horrible.

I think that it'd be better if they made this show only with surveillance cameras. It's not like people alter how they act for the cameras, but the second a camera comes around, a switch goes off in your head. You're asking yourself if this is going to be broadcast. Let's say I get into a huge fight with someone. As I'm watching their lips move, I'm thinking, *This is going to be an episode.* Cara used to call it feeling "episodical."

I'm worried about Tonya. She doesn't know what's going to hit her when the show airs. She's the big-breasted blonde who all the perverts are going to obsess over. She's got a Baywatch body. She's in the opening montage in a bikini. At the wrap party Tonya was like, "I don't like people coming up to me wanting to take pictures, being a celebrity." Mike from the New York cast was there. He was like, "You better get used to it. That's what your life is going to be like." She told me she thinks it will be different in Walla Walla. I was like, "Tonya, you're going to be the queen of that town."

I'm also worried about Chris with the being-on-television stuff. He's very vain. He's caught up in hearing he's hot. Stay

I'm so proud of us!

My biggest fear is that people will prejudge me because of labels. Nothing bothers me more than when I'm stamped Mr. Elitist Football Player.

WANNA BE SEEN AS:

I hope, above all, I'll be perceived as classy, a complex person who was genuinely interested in my roommates. I want to be seen as doing the right thing, being mature. I want to be seen as a red-blooded regular guy who's got a complex side to him.

Cast Speak

Cara: I f**king love Kyle. I adore him. I've had guy friends before, but if they are this close, I'm usually sleeping with them. I think he's so funny. Everyone thought he was the person who acted the most for the cameras, and I don't know about that. I considered him really honest. He just says it like it is. He's a pensive guy. Keri called him political and I can see why she would say that. His delivery sounds so planned out, but I admired that. I just blurt stuff out. I like that he's so in touch with his feelings. Family is really important to both of us. **Will we keep in touch?** Hell, yeah. I want all my roommates to be at my wedding, but I want Kyle to be friends with the groom. I want him to be part of my life for a long time. I want my kids to call him Uncle Kyle.

Tonya: I loved how brotherly toward me Kyle was. He was always looking out for my best interests. In a bar, if a guy was harassing me, he'd step in. He comes from a wonderful family. He has had the life that most people would die for and he still has no idea what he wants to do. That seems crazy to me. If you asked me who the phoniest person in the house was, I'd have to say Kyle. He tried really hard and I found it frustrating. He did stuff 'cause he thought it would look good, and encouraged us to do the same. **Will we keep in touch?** Probably not. I've done these transi-

the same sweet, caring Chris! Be careful with that stuff. Stick with your recovery. Don't get caught up in being a superstar.

At the wrap party, we met some former cast members. I talked to Amaya from Hawaii. She didn't seem that interested in knowing me. And Jamie from the New Orleans cast told me he thought Amaya considered us competition, fresh new faces pushing her to the back of the line. Amaya said that her cast didn't talk to each other when the show was over. That couldn't be further from us. I'm so proud of us!

What I'm going to do now is spend a lot of time with my loved ones and Nicole. I'm going to try and keep stuff in perspective. I spent my entire senior year worrying about what I was going to do next. When all my friends were becoming investment bankers, I opted to go on *The Real World*. I'm open to whatever's next.

tions 12 times over. Moving out and going to another place is comfortable for me.

Keri: Kyle's a nice guy who has a lot of growing to do. If our relationship is going to be a friendship, then it's up to him. Kyle's got a strong aura. There's a hint of inexperience behind it. I don't think he knows how to get his point across strongly. I think he's funny, really funny. He can be boring at times, but everybody can be. I loved his family. I don't want them to look down on me, but I don't know if I can care anymore. ***Will we keep in touch?*** The ball's in his court. He had the issues, not me. If he's forgiven me for my indiscretions, then he's my friend. I'll invite him for Mardi Gras with everyone else.

Aneesa: Kyle's so gorgeous. He's really so beautiful. We both agreed that we wished we had more time together. I think we avoided each other a bit during the season—maybe because of him not thinking I listened. We appreciated each other's dirty humor. He'll say stuff in a straight voice, but it'll be so nasty. ***Will we keep in touch?*** Yeah, and hopefully I'll meet Nicole.

Theo: Kyle's just an awesome guy. He's so talented, he's funny as s**t. He uses his knowledge, but doesn't try to slap you with it. He's like, "Yeah, I went to Princeton, I played ball, blah blah...." Kyle is the type of guy who's going to succeed at what he wants to do. He is goal-oriented. ***Will we keep in touch?*** Definitely, we'll keep in touch, I'm sure of that. Monday Night Football, we'll talk. That's my dawg.

Chris: Kyle's very charming, witty, and intuitive, and in many ways undecided. In the beginning, I didn't know if his intentions toward me were for the camera or not. He was really supportive in terms of my sobriety and my recovery. But I was wary. He's got a manipulative side to him. He held back a lot during production. He wasn't in the moment; he was in the edited moment. ***Will we keep in touch?*** Yes, definitely. Our friendship will stay strong.

Crew Speak

Anthony Dominici: Kyle was a really great cast member. To be honest, I wasn't expecting much in the beginning. He's the all-American guy and historically it's been difficult to cast the straight white men— they're not usually in touch with their emotions. Kyle shared everything with us and in the process learned about himself. He's not the same person he was when he walked in the door. I think he gravitates toward being the all-American guy who's a provider, and I think he has to realize that he doesn't have to be all the time. He's still young; he shouldn't deny his own happiness.

Jon Murray: I hope we told an accurate story about Kyle's conflicted feelings toward Keri. He was doing so much damage control with everyone to try and control the way the story would be told that it may never be possible to know exactly what was going on in his head. As producers we tried to tell as complete and truthful a story as we could. I think most viewers will understand Kyle's conflict and respect him for being concerned about how his ex-girlfriend would deal with his relationship with Keri.

Mary-Ellis Bunim: I found Kyle at an open call at Princeton and knew immediately that he would be on the show. There are few people on this planet who are as handsome, well-educated, articulate, and self-possessed. We certainly haven't heard the last of Kyle. I predict he'll be in the public spotlight again in an important way.

Tonya

Tonya: I didn't relate to any of my roommates. That doesn't mean I didn't get along with them or admire who they were or learn from them.

But I definitely didn't click with them. We didn't have a lot in common. They're not like the people in Walla Walla, and frankly, I can't wait to get back to people who want to work their a**es off, and pull straight A's, and rock-climb—people like me. I don't see anything wrong with that. It's not like Theo didn't flock to people like himself every night, people who stayed out until 6 AM and partied all the time.

According to my roommates, I was a recluse. But I'm not a partier. And I'm proud of myself for sticking to my guns. Anyway, I don't think I missed much. I think my roommates had really superficial relationships. I didn't find the conversations they had deep or soul-searching. If you ask me, I think the relationships were mainly for the cameras.

It was hard for me. I'm only 21 but I feel a lot older than my roommates. My life experience makes me feel older than I am. I feel like I've been through everything my roommates are going through and then some. I even told them, "I've put on every mask you've ever tried, and that's why I see through you."

I saw my roommates as insecure. They felt happier when the cameras were on them. Not me. I was pleased when the cameras were turned off. I thought, *Good for you, Tonya, you made it through another challenge in your life. Thank God.*

The cameras were not important to me. I like the small things in life—going on a hike, taking a walk. I'm not into all the materialistic and superficial stuff that dominates my roommates' lives. Take the girls.

They were so into shopping. They would buy stuff all the time. They had the financial support to do so. Well, I didn't have Daddy's credit card, and, anyway, I don't need that stuff to feel good about myself.

I learned a long time ago not to need labels to feel secure. The other girls in the house were all so chichi. On the second day, I looked at Cara carrying a purse; it was blue and gray plaid. I said, "That's the ugliest bag I've ever seen." Her response? "It's not ugly, it's Gucci." That's the difference in our mentalities. If you need labels, then you're not as confident as you think you are.

They had all these beauty treatments. We'd go to Walgreens. The cameras didn't have permission to shoot there. Well, the other girls saw this as an opportunity to pluck their eyebrows without being seen. They'd tweeze right there in the aisles. Who cares if people see you plucking your eyebrows? It was hard to stomach.

The girls carried around makeup with them and were always reapplying. We'd be going to the gym and they'd have to put on lip gloss first. And if we went out at night, they'd have to change, like, nine times. It was a four-hour production. I didn't need to do all that work. I thought I was beautiful just being me. Then again, I was the only girl who wasn't single. I didn't have to go out and turn heads. I had the security of knowing I was loved.

I guess if I had to pick the person I most related to, it would be Cara, because we had the same body image problems. Next would be Aneesa, because of how she has to prove herself to her mother and the world. I think I was lucky to not have to prove myself to anyone. I didn't have anybody telling me how to act in order to protect their family, just to keep it together.

I had to be accountable to me and to Justin, who's just so supportive. So I had nothing to lose by being myself.

I really think that's why I was the most honest of all the roommates. I think that for the most part, they all were acting a lot. I had no reason to fake, to try and be consistent. And when I got sick, I wasn't able to put up a facade. I didn't have the energy to be anything but myself.

If I hold myself accountable to anybody, it's to people who grew up in foster care. I had to be real so that people could understand what growing up in foster care does to you. I wouldn't say I altered how I behaved for the cameras. But I definitely thought about the kids who'd be watching me.

For example, I wasn't naked as much as I would have liked to be. The thing is, I hate clothes. But I knew that kids were going to be watching, and I knew I needed to respect my body and not advertise what's not for sale. I wanted to set a good example.

The only thing I'm worried about is this: I don't want people to feel sorry for me. I know being sick made me seem like the cliché of a foster kid, someone who just wants attention. Well, yes, I want attention but not because I'm a girl from a hard-knock life, but because I've been through a lot and came out stronger, with more intensity.

I'm glad my time in front of cameras is over. It's nice to have that privacy back and feel like I don't have to be conscious of the message I'm sending out anymore. I'm going to go back to Walla Walla. I'm going to be in the profession that's meant for me: medicine. And, most important, I'll be with the man of my dreams.

SCARED I'LL BE SEEN AS:
I'm not scared of anything.

WANNA BE SEEN AS:
Strong-willed and caring.

Cast Speak

Theo: Tonya is the most sheltered person I ever met. I hope she had a growing experience in Chicago. She made me see how good I have it. She showed me how good a life I've had just to know my parents. You gotta respect that she stood up for herself. She never backed down for a moment. I appreciate that. I hope Tonya learned that all black males aren't what she thinks. She and I had our fallouts but I hope she honestly saw that I loved her. ***Will we keep in touch?*** I hope so, but of all the roommates, I'll talk to her the least.

Keri: At first I thought I might have a problem with Tonya because she looked like the dingy cheerleader blonde. She definitely proved me wrong and that was a good thing. No matter what, Tonya was real. She could be a bitch or she could be cool, but she was always real. That's why I like her. She stuck to her guns. I definitely think there were moments when she was annoying, but there were moments when everyone was. Sometimes I feel like I'm the only one of the roommates who really liked her. ***Will we keep in touch?*** Once in a while, yes. She always has a home in New Orleans.

Aneesa: What did Tonya get out of *The Real World?* Nothing. OK, exposure, for God knows what. But, I can't figure out why she did the show. I definitely would not have been friends with her in any other scenario. I guess that within time we learned to love each other. She's a sweetheart, she means well, but she has a really bitchy side to her. Whenever she was healthy, she was a bitch.

She never wanted to be part of anything. **Will we keep in touch?** I don't think she'll call me back when I call. I guess she really just cares about herself.

Kyle: Tonya's a strong woman who can be nurturing and caring, but she's razor sharp around the edges. Her time in Chicago irritated me. As soon as she got there, she was counting the days. I don't like hanging out with her, but I wish her the best in life. I really don't know her very well. Once she brought out these pictures of her estranged mother and siblings. I'm an inquisitive person and I started asking her questions. She snapped at me and told me I was being rude. I was expressing a genuine interest in her family, and she tells me I'm rude. Kiss my a**. What have *you* ever learned about *me*? **Will we keep in touch?** I don't think Tonya will keep in touch with anyone. She might surprise us, but I think she's ready to move on. And I think her chances of keeping in touch with us will be even slimmer once she sees the show.

Cara: Tonya's loving when she's loving and horrible when she's horrible. For the first few months, I tried just to focus on the wonderful. But then I could only go so far excusing her because of everything she'd been through. We had nice talks lying in bed in our room. She can give good advice but she acts so worldly, like she's been through so much. Of course it's true, she has dealt with a lot at a young age. Truly, I can't commend her enough. But, at the same time, she would be pretty critical of others. I wish only the best things for her—Justin, motherhood, everything she wants. **Will we keep in touch?** Probably a little.

Chris: Tonya always had one foot in Chicago and one foot back home. She was always on shaky ground. She was constantly holding on to Walla Walla and using it to validate herself as a person, as opposed to exploring Chicago and seeing what Chicago had to offer. She's very closed-minded and strong-willed; she sets goals and gets them done. She respects my will and my drive and my sobriety, just as I respect where she's coming from as a woman and a person who has survived so much. **Will we keep in touch?** I hope so. I worry about her and wish her the best.

Crew Speak

Anthony Dominici: Tonya's going to learn the most from watching the show, not from being on it. Tonya was a very different person in Chicago than she was in casting. When we first met her, she was more of a wild child. She wasn't even with Justin. Once she got back with Justin, she realized she had a good man on her hands. I think she made a decision that her story would revolve around "being the responsible one." I don't think we saw the best of Tonya in Chicago. She admits that. I think she was sicker than even she realized. She is incredibly intuitive, a really smart person, but I think sometimes she doesn't trust how smart she really is.

Jon Murray: Tonya is one of the most fascinating cast members ever to be a part of one of our shows. You can't take your eyes off her because you're never sure what she's going to say or do next. I think she's still somewhat of a mystery for most of us, but she's a mystery I wouldn't mind spending another 22 episodes trying to figure out.

Mary-Ellis Bunim: My heart went out to her every day that I heard she was feeling ill. *The Real World* is such a stressful project and you have to be at the top of your game to take it on and enjoy the experience. Between her pain and her medical bills, how did she get through 5 months of this? I'm just glad she's back on her feet, physically and financially.

Progress, not perfection, that's my life today.

Chris

Chris: After going through everything, I feel very strong, very capable. When I said yes to being on *The Real World*, I was early on in recovery. I should have just been thinking about myself solely, but I decided to take on something bigger. By coming to Chicago, I took on more responsibility. It was very daunting. I was scared of being without my family in a different city. I was scared of relapsing. I was scared of feeling accountable to the gay community.

I'm a very private person, and throwing me into this mix really affected me. All my roommates dealt with the cameras in different ways. Kyle slept a lot. Keri was unhappy. Cara was really OK with the process, but she's good at hiding her feelings to begin with.

It's been nine months since I went sober and each day I feel a little more centered and grounded. A lot of my change is due to the strength of going through this experience. You have to be on 24/7. The cameras represent the viewers, and they really mess with your head. I would get so nervous, thinking about what I was saying and how it would come off. But really, I feel I held nothing back.

What people will see is my life. In the beginning, I was shunned away from AA because the process of *The Real World* is sort of against the principles of AA. Anonymous people don't want to be filmed. That gave me a lot to worry about—like relapsing if I didn't have an outreach program, a safe place. I had to worry about my safety first and foremost. I was lucky in a way—the cameras weren't allowed to come to AA.

My roommates did nightly partying, and they reminded me of just how I used to be at their age. On a Tuesday night I don't see the point of staying out until 4 AM. There's a huge difference between the ages of 19 and 24. I don't really see the point of going out during the week; I don't see it as that much fun.

There were times that I was woken up late at night. It was an adjustment period, to sleep when there are cameras walking around and people coming home late. When the cameras come into your room, it's like in Jurassic Park, when the door opens and you hear the raptors coming.

There were times when they'd complain that I didn't want to go out. I'd go out three times a week, and they'd go out at least five. I don't need my friends to give me a hard time about that kind of stuff. They'd take it as an insult that I had to go to a meeting. But if I didn't have meetings, I couldn't be in the club environment even two times a week.

I don't think I was ever the person who judged them. I hate people who condemned me for going out when I did, so I wouldn't do that to them. All I did was offer my experience as an example. Kyle and I would be lifeguarding and he'd be like, "Oh my God, I can't believe I'm hung over again." Well, there's an obvious answer.

When the group went to Cara's house in St. Louis, I went back to Boston for my grandmother's funeral. I'm sad the show didn't have the chance to see my mom or the special relationships I have with my family. It's very beautiful how supportive of me they are. A lot of people, when coming out, get cast aside by their family, and I have so much support. My parents know absolutely everything about me—boyfriends, drinking, everything. My dad's been in and out of AA himself, and through my

I feel that being in the house, I had to regress.

Cast Speak

Aneesa: Mr. Chris, he's great. He's my buddy. I think *The Real World* was a positive experience for him. I respect his strength to stay sober in such a stressful environment. He's a great friend who cares about people very much. He's also anal and compulsive. He sometimes made me worry. I think there's painting and modeling in his future. I won't be surprised if Gucci calls him up. **Will we keep in touch?** Yeah, he lives in Boston, which is close enough.

Cara: What I loved about Chris was that he would do stuff on his own. He's an independent explorer and I think that's really awesome. Maybe it's because we're both Geminis, but Chris and I were really close in the beginning and not in the end. Our evil twins came out, I think. He could have gotten more out of the experience in Chicago. He removed himself and was more reserved than the rest of us. Maybe because he's older and has lived on his own, he deemed it his right to criticize my behavior. At one point, he was like, "Do you need alcohol to have fun?" I was like, "No, but it sure helps." Even when we were leaving, he told me to be careful. He made me feel defensive. Don't be so patronizing! **Will we keep in touch?** A little bit. He's a sweetheart, but I don't know how often we'll speak.

Keri: Chris is a really nice guy and a really good listener. We had some excellent conversations. He was the entrepreneur of the group. He was always networking and working

experience I've given him hope for his own progress. You can't ask for anything more.

They also made a lot of fun of me for being so compulsive about working out. There are things my recovery requires: going to meetings, having a huge support circle of friends, and having a healthy body. Definitely there's some compulsiveness involved in taking care of my body and going to the gym. If my roommates think that's a vice, I don't care.

I feel that being in the house, I had to regress. The only other person who'd really lived on her own and had responsibilities was Tonya. She'd done things like pay bills and grocery-shop. I felt much older than the other roommates in that respect. I've been on my own a long time.

There's still a lot of learning and growing that I need to do as an adult.

toward his success. Chris is working with a famous artist and I think he'll have a lucrative career as a painter. He should never let people tell him his addictions to working out and coffee are bad. He's got so much willpower, more than I could ever possess. *Will we keep in touch?* I want to go to his gallery opening. We'll e-mail, yeah.

Kyle: My friendship with Toph is what I'm most proud of. He prejudged me and got me very wrong. I guess if you look at the stats, I'd be someone who wouldn't like gay people. It was satisfying for me to prove him wrong, and then for us to go on to become such good friends. He's a great listener, and that's a great commodity in *The Real World* house—kind of the antithesis of Aneesa. He's the most selfless person in the house. It was frustrating how much he worked out. There were countless times when we asked him to do group activities, and he'd be like, "Nah, I want to go to the gym." He missed out on an important experience because he had to do cardio. His relationships with the roommates will reflect that. But Toph's my boy. *Will we keep in touch?* He's gonna live in Chicago, so I think we'll get together and watch the episodes together.

Theo: Toph! I call him Bitch Daddy and he calls me Fancy. His and my relationship got really, really tight. He's a good person, a good friend. I'm still not cool with the gay thing, I think it's nasty, but he's still my dawg. I thank God it hasn't messed up our relationship. I want him to think, *Theo don't like what I do, but he's going to be my friend regardless.* Simply that. Chris sees things as beautiful and he's made me notice things more. I appreciate beauty more because of that man. *Will we keep in touch?* We have too much in common not to.

Tonya: Chris is independent. He can live on his own. We liked going to the gym together. He's a survivor, and I'm attracted to people who can survive life. *Will we keep*

in touch? I hope so. If I had to live with one of my roommates again, he's the one I'd pick.

Crew Speak

Anthony Dominici: We knew Chris had a lot of issues coming into the show. We also knew we were going to have a tough time telling his story. His recovery program is anonymous and we respected that. He brought maturity to the house. He was also the most clever of the roommates when it came to getting away from the cameras. Honestly, I think he was sneaking away from us as well as the roommates. I wish we'd seen him paint more. I think he was slightly self-conscious about painting on the show for whatever reason, I'm not sure.

Jon Murray: We were worried about putting Chris, a recovering alcoholic, into such a stressful situation. But when he came to the final casting interview, he had already lined up a sponsor and checked out support groups. That act of maturity convinced us that Chris could handle the stress of *The Real World*. I'm glad we could include him, as his story is an important one for our audience.

Mary-Ellis Bunim: Once Chris opened up, he turned out to be a great friend to everyone, always lending an ear and a sympathetic shoulder. I think he added maturity and was often a wonderful role model for his roommates—and the viewers.

The biggest lesson I learned: Listen to people.

Aneesa

Aneesa: I hate to say it, but I miss the cameras. As annoying as having that bright-a** light in my face was, I miss it. I liked having an entourage. I liked being known.

Whenever I left the house, I got a reaction. It'd be either "F**k *The Real World*" or "I love you guys!" Most people would talk to me just because the cameras were there. I'd be in a club and hear, "Oooh, there's the *Real World* girl." I'd be like, "No, I'm Aneesa." It's kind of annoying to become an entity not your own. But I couldn't be mad; I got myself into this.

I was fine about the cameras. Yeah, sure, we tried to get around them. We passed notes some times. Or we'd mess with the crew. If I wanted to hang out on my own, I'd tell the crew I was going to have sex with a girl, so they wouldn't come. I wouldn't have sex, I'd just go to the club.

I came out senior year of high school. I feel bad because it wasn't hard. I know a lot of people struggle with it. At the time, most people thought it was a phase because I'd dated a lot of guys. I think I dated a lot of guys in order not to deal with it. I had my first crush when I was in ninth grade. She was a senior, and oh my God was she beautiful. She had a girlfriend from out of school and I wanted to know everything about it. I developed a huge crush on her. She was the most incredible thing. I'd always think, *You'd have to pay me a million dollars to kiss a girl, but not her.*

I first kissed a girl when I was a sophomore. I went to a girl's house one night and her mom was away and we just kissed. I was cool with it. We were both curious. We both thought, *Yippee. That was fun. Let's do it again.* We got a bunch of friends into the mix and all started kissing. I was still into guys. I even got a new

boyfriend. He was cute and tall, a partier kind of guy. I was faithful to him, but he wasn't to me. We dated for eight months. It was on and off for a while. Senior year, I met a girl who was a friend of a friend and I cheated on him with her. She was the first girl I slept with. I told him about it, and he was like, "You have to choose."

I told him, "Well, I can't live without women but I can live without you." So, good-bye. The next day, he and I tried to be intimate—a last-ditch-effort kinda thing—and it just didn't work. It was horrible.

Am I a drama queen? I wouldn't say that. There's just a lot of crap that goes on in my life. I learned in Chicago that drama is not needed all of the time. Sometimes it does make life interesting. *Do I think I manufacture drama?* At times. I don't know. I guess I get bored. I don't know if boredom motivates me to talk to lots of girls. Actually, I don't think I do that anymore. I have more respect for myself and other people. I used to talk to a bunch of girls at a time, and then eliminate ones that I didn't get much from.

If I have a personal philosophy, it's this: Live each day to the fullest. Don't concentrate on the past 'cause it will make you miserable. Regret only the things you should have done, not the things you shouldn't have done.

I want people to see that I wasn't fake on The Real World. *I was all out there. I'm blunt and there might be a lot of drama. Maybe someone will relate to that. If one person gets something out of me being on the show, then I'm happy. I don't need the whole world to love me, because I know they won't.*

I hate to say it, but I miss the cameras.

I don't want to be portrayed as the s**t-talking bitch. I'm not just that.

A good person. Even though we all had our share of fights, I want them to see the positive stuff in me.

I'm going to go back to school. I'm in a singing group and in a band. I'd like a singing career, sure, but I have patience. Music is everything to me, but I didn't go on *The Real World* to get a career. I don't want to be on *TRL* 'cause I was on *The Real World.* That's pathetic. If Tonya said I went on the show 'cause I wanted a singing career, then I'd have to ask her why *she* went on the show. So everyone could start a Feel Bad for Tonya Fund?

I sang on *The Real World* because that's what I do in my everyday life. I love music more than anything except my family. But I'm not trying to be an actress or anything. Tonya's just mad because she's got no talent and actually does want to be in the entertainment industry.

What sets our cast apart from others? A lot of sex. Just joking! I think the fact that—aside from Tonya and Chris—we're all funny as hell. I think the fact that we were on *The Real World* during Sept. 11 is going to really make things different. We lived through tough times. We're young. We're the new generation.

Cast Speak

Theo: Aneesa is my heart, my love, my sister. I can go to Aneesa and talk about stuff. I've never had a woman in my life who can listen like that. I do feel she runs her damn mouth too much. The key thing with Aneesa is that when Nanu finds out who Nanu is, when she accepts herself for who she is, she's going to be so awesome. I look at her and can break into tears. I would take a bullet for her, and I mean that. *Will we keep in touch?* She's the person who I know I'll keep in touch with the most.

Tonya: I think Aneesa's a pretty neat person. I have to say, though, the way she's been raised has made her seem, well, selfish. Actually, she's the most selfish person I've ever met. She wouldn't clean. She wouldn't buy toilet paper. She'd borrow from everyone—cell phones, money. But I think she grew up a lot in Chicago. She's good at reflection. She's on a journey that's cool to see. I see myself in her. I'm still on that journey but I think I'm further along. I admire her for being able to say, "I'm gay, Mom" over and over again. At 19, I couldn't have done that. *Will we keep in touch?* I'd like to see how she turns out. But I'm not going to go to Philly to hang out.

Cara: Kyle noticed that Aneesa was the girl who cried wolf. She was never hungry, she was famished. She was never tired, she was exhausted. That's how she was in relationships: all about extremes. She was in love or heartbroken or the girl was *such a bitch.* I

don't want to sound condescending, but she still lives at home and she still, well, lives at home! I think she is really talented. She kinda reminds me of myself a few years ago—spunky, out there, a more exaggerated version of me. She has an amazing voice and I do hope she pursues that. I think she's got a lot of sensitivity. She's a better listener than anyone ever gave her credit for. Her worst traits are that she's selfish and lazy, but when she's not those things she's amazing. *Will we keep in touch?* Totally. I think we'll continue talking. I'm on the East Coast a lot.

Kyle: Aneesa's a little girl who wants attention. She's the biggest drama queen in the world. Nothing about her is nonchalant, nothing is blasé. Maybe it was the cameras that weren't giving her enough attention, or maybe it was us. She's exactly the kind of person I wanted to live with, because she's so different from me. We'd do a lot of dirty talking. I'd say, "Daddy's going to turn you straight, little girl!" I have so many images of us talking—me in my boxers, her in a pink thong—doubled over with laughter. I needed her in the house. I could always count on her to make me laugh. Our relationship was definitely not a deep one, but she's someone I care about so much. I care about her more than most of the roommates. *Will we keep in touch?* Absolutely.

Keri: Aneesa is funny as hell. Oh, my God, she reminds me of myself when I was 18. She thinks she knows what's right and what's wrong. She shows her emotions much more than I do, and I appreciate that. I very rarely bond with girls, but I think we'll always be friends. Nanu's awesome. *Will we keep in touch?* We're gonna try and talk every Sunday night.

Chris: Aneesa is wonderful and outrageous with a good, kind heart and a gentle soul, with lots of love to give and get. That said, she has a lot of growing up to do. Everything's always

all about her. We had some deep discussions, though. *Will we keep in touch?* Yes, we'll definitely keep in touch via e-mail and seeing each other here and there.

Crew Speak

Anthony Dominici: Aneesa grew the most through this process. I think she had a great experience here. She's only 19, still a kid. I adore her and think she's a great person. What really strikes me about her is that she strives to be different. She's very, very brave. She doesn't apologize for who she is. I have no idea what's going to happen with her, and I think it's going to take a while for her to settle in and find out who she is—that's not a bad thing. I wish her all happiness.

Jon Murray: Without a doubt, Aneesa is one of the most compelling people I have ever met. She's tough but vulnerable. She can make you mad one minute and make you laugh the next. Aneesa is a reality-television producer's dream. I'm looking forward to watching what she does next.

Mary-Ellis Bunim: What makes someone a successful participant from the producer's point of view? Uniqueness. The lack of "filter" between someone's brain and tongue. Anessa would continuously leave us open mouthed, just amazed at what she would do or say, She's so out there, funny, smart and brave.

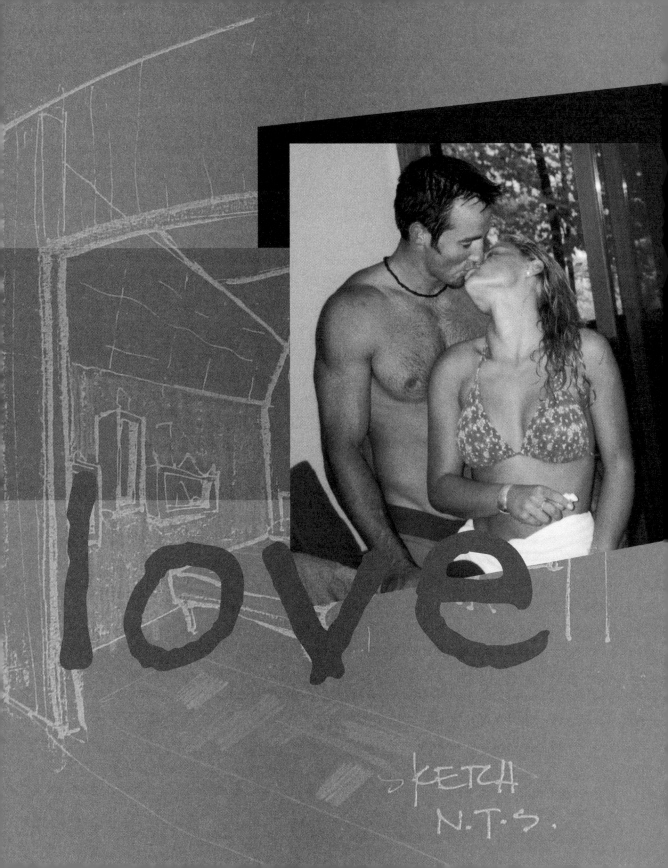

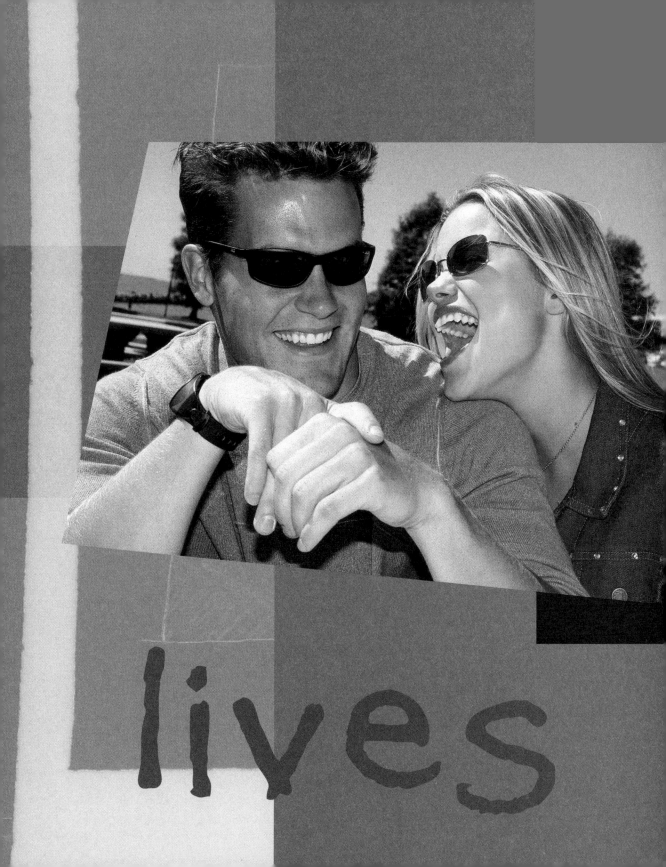

lives

Keri & Kyle

Keri: My friend Julie came to visit and she was like, "C'mon, Keri, would you ever have dated that guy under other circumstances? You wouldn't!"

Keri: I feel as though people want me to say that I regret Kyle. But I don't. That's because not much happened. We were attracted to each other. So what? I'm sure Kyle's trying to make it like I was really into him and he didn't like me so much. That's not true. It was mutual and it was really short. It was two weeks.

At interviews, they would ask me solely about Kyle and it messed with my head. *I know it's going to look like we we were the relationship of the house.* And I'm pretty sure it's going to look like Kyle was running the show and that I was lovesick over him.

I felt like the girl in high school who the jock slept with and then ignored—*except we didn't sleep together.* Kyle's sexual past is not very complex. I think he's dated two people seriously and that's it. He's never gone out on dates. He acted like it was me who kept him from expanding his horizons while he was in the *Real World* house. He'd tell me we hung out too much, and that I was keeping him from going out and seeing the town.

I don't want to rip him apart, but he is immature and was worried about stupid stuff, like how he was going to look on camera. I don't know everything, I'm too friggin' young to call someone else immature, but I know it's normal to date around when you're young. He's been handed a lot by the fates. He found the person he wanted to be with in his sophomore year in college.

I would tell Kyle, "C'mon, let's not do this. It'll be much better for me to find a heart that's not taken by someone else." *He's the one who pursued this.* I knew it was not going to happen while we were on the show, and now I don't think it's ever going to happen at all.

When we liked each other, he'd be very on and off. When the cameras were around, he wouldn't want to hang out with me. But then sometimes he would. It was very confusing. I don't know about Kyle, but I saw the Hawaii season, and Colin and Amaya looked like they were this huge couple. I thought, *That will never be me.*

We got along so well, and we didn't even know whether we liked each other yet, but we did know that every time we hung out together, the cameras followed us. That affected our relationship. He'd shy away from the cameras. I'd get pissed off at him and tell him to show the camera we were just friends.

We got into this huge fight. On the surface it looks like what we're fighting about is whether he'll come downtown with me to pick up our work checks. But what the fight is really about is the cameras. He didn't want to come with me, solely because he didn't want us to be followed by the cameras. *The cameras ruined whatever friendship we could have had.*

Another example: Kyle, Cara, Chris, and I were out to dinner. Cara and Chris were talking about the fact that they were attracted to each other and wanted to get it on and make out. There they were talking

about their unrequited passion, and the cameras were focused on me and Kyle. And what were we doing? Something exciting? No, we were paying the bill.

I never tried to deny or hide the fact that I was attracted to Kyle. But he tried to hide the fact that he was into me. I'll look like a lovesick puppy and he'll look like he was holding back. He tried to cover his a** by telling the roommates I was coming on to him, slipping into his bed and stuff. He made me look pathetic to the other roommates, hoping that those conversations would end up on the show. Come on! What a lie.

There was only one night when Kyle and I slept in the same bed. Whatever. He slept in Cara's bed like nine times, he would fall asleep in Aneesa's bed all the time. One morning, I got under the covers with Kyle and was shaking him to get up. I'd just gotten out of the shower and had

been in the bed for a minute when the camera crew walked in. It's going to look like we woke up together. Whatever. It's not true.

Is Kyle a good kisser? You know how sometimes when you kiss somebody they either have great lips and terrible tongue, or the reverse—well, he wasn't bad in that kinda way. It's just that no fireworks exploded. Kyle and I never made out in the house. *We wanted to kiss, but we didn't want to do it in front of the cameras.* Our first kiss was in a bar somewhere. We didn't want it made into this huge issue. The cameras were following Aneesa around, so we took the opportunity to kiss. It was no big deal. It was very inno-cent. We didn't kiss for very long. It was like a good-night kiss after a date. Another time we made out in the back of a taxicab. The cameras missed that, too.

Kyle told me not to do certain things in front of the camera. He didn't want to hold hands or lie next to each other in the house. He didn't want them to pick up in any way, shape, or form that he liked me. He and his girlfriend had broken up, and he still wanted to make her happy. I really do think that if our attrac-tion hadn't gotten in the way, we could have been good friends. *I could have overlooked the attraction; he couldn't have.* I just stopped worrying about our relationship and started worrying about me.

Kyle looked down on me at the end of the season. He judged me for dating guys. It was OK for Theo to do it, but he'd warn Cara and Aneesa and me that we'd be portrayed as sluts. *I don't know if that's sexism or simply inexperience.* I don't know that Kyle's ever had close female friends. He had two friends from high school who were girls, and he saw them twice the whole time he was there. And they lived in Chicago. I'm not trying to judge Kyle. I'm just not in the place he's in anymore. And I'm not saying *I* thought this—I'm really not—but a lot of people questioned whether Nicole and he were really so in love. Why didn't she come visit?

As for them making a story about Cara, Kyle, and I and there being some triangle... whatever. About three years ago, I was dating a guy really seriously. We used to hang out with another girl all the time, a close friend of mine. They ended up sleeping together. I feel like I carried that grudge with me into the relationship Kyle, Cara, and I had. Cara's so cute and so funny and everything a guy would want. I guess I might have thought Kyle was into her, but I was never jealous of Kyle and Cara. *It was nice to see them become such good friends.*

...no fireworks exploded.

I worried about Kyle's feelings more than I worried about anybody else's, and that started to make me crazy. By the end of the season, I just didn't want to worry about my relationship with him anymore. I accused him of being phony and it was a disaster. I should have said stuff in a more sugarcoated way. The truth was, I'd been meaning to talk to him for a while. I wanted to know if he thought we'd be friends after the fact. And I wanted to find out if he'd done stuff for the cameras. *I was absolutely wasted and ended up blurting out accusations and being tactless.* Everything I wanted to say came out in five minutes of insults. Tonya said that Kyle told her he'd invited his little brother over so the cameras could see the brotherly side of Kyle. I'd also heard he applied to be a substitute teacher, so it could get on camera. I ended up telling Kyle that he was fake. There's definitely an element of politician in him. I think Kyle was working on his political career the whole time he was in the house.

Anyway, it ended up being a crazy conversation. I fumbled everything I'd thought about saying. I ended up hurting Kyle's feelings very badly, then feeling really guilty. It was just awful. I don't know if I lost a friend because of that conversation. *Friends forgive each other for their faults.* I know that if I'd done something like that to Aneesa or Cara, they'd talk to me about it after and eventually forgive me.

When I got back to New Orleans, I didn't know if Kyle and I were ever going to talk again. *But he actually called me on Christmas Day.* I was glad to hear from him. There was no innuendo, no messed-up stuff. It was just cool to finally talk. I guess when it comes down to it, we were friends above all. Now, I think maybe it was the show that messed everything up. Being asked constantly about the relationship really affected our behavior. I'd always be standoffish after interviews because of how they messed with my head.

We're gonna talk now. He's gonna try and come to Mardi Gras. I invited Nicole, too. I'm dating someone now, a marine actually; he lives in New Orleans and it's cool. I just wanna be friends with Kyle. *I'd rather we never hooked up again.*

I was attracted to Keri, and made some poor choices as a result. We were not a romance. I define our relationship as people who had similar interests in each other, who flirted. *She was not my girlfriend.* We were very touchy-feely together, yes, but I didn't really want to do anything about it. I don't even know if I would have gotten into it with Keri if I'd had my wits about me. Seriously, when I got to Chicago, my head was spinning and my feet weren't on the ground. Our relationship snowballed as a result and I hate that it did.

Initially, I took to Keri's loudmouthed beer-drinking personality. *In retrospect, I realize I liked it because it was novelty for me.* The same things that I liked about her in the first month, I hated in the last month. In the beginning, it was fun. She liked going to bars and drinking shots. She was right there with me drinking shots of Jack with beer.

Our flirtation was just immediate. We would write each other little notes. Sometimes they were just stupid, catty, flirty notes, like sixth grade "write back!" kinda stuff. But sometimes I'd write her notes saying things I didn't want to say on camera. Things like, *I don't want to hang out with you.* I didn't want do that stuff for everyone to see.

I know the flirtations I had with Keri are going to be squeezed for every last drop and that frustrates me. I suppose I should have known that going in. I really resent the fact that because we had some fun together, we're now the *Real World* romance. *I hate that.*

I had a lot of fun with Keri in the beginning, but the more I got to know her the less I wanted to be with her. I know people think I'm marginalizing and belittling it. But really, it was only this: There was a girl in the house who really, really liked me. We hung out. End of story. *Actually, usually we hung out by default.* In the beginning, Chris and Aneesa were always going to gay bars, Tonya was staying in and talking on the phone, and Cara was hanging with her friends from Wash U. It was frustrating. So, Keri and I would be stuck together. The cameras would be all over us. They'd do anything to get us together. They'd film us reading newspapers.

In the beginning I didn't know what she was like, but the more I got to know her, the more she annoyed me. She'd always say, "Kyle, come and sit with me....Kyle, come over here." I was too nice to her. I should have been more willful. If I said I was going to get something to eat, she'd wanna come with me. She was so hooked, and I was trying to protect her feelings. I'd wish I hadn't. I regret it.

Kyle: The show ended, and I didn't talk to Keri for a couple of months. I'd talked to all the roommates, and I felt weird that I hadn't talked to her. It was the holidays and I just wanted to wish her well and happy New Year. We've never addressed the terms on which we ended, and I don't plan on addressing them. I have no intention of going to Mardi Gras. I don't want to rectify any of the problems we had because I don't really care.

I don't think she would mind if we hooked up again, and I would never ever do so again. That drinking, cussing, bartending thing wore on me. I need a woman with a little less crass and a little more class.

People in the house seem to think Cara was attracted to me, that she wishes I was attracted to her and such and such. But I was never physically attracted to her. I love her hair, I love the way she dresses. I know she's a lot of guys' dream. She's so thin and tight and can wear sexy clothes, but I don't like women like that. *Her body type was exactly what I don't like.* I have the feeling Cara wanted to make out with me; the feeling is not mutual. If it's going to play that there's something between us, well, that's fine, but all the roommates know it's not true.

Keri was very envious of my relationship with Cara. If she came between me and Keri, then I'm glad she did. Whenever I was hanging out and having fun with Cara, you could bet that Keri would come in. *She'd ask me why I didn't laugh and hang out with her like that.*

At the end of her time, Keri became really spiteful. She called me phony, and I think that's so stupid. She thought that me wanting to do substitute teaching was a camera thing. Whatever. I wanted to change the nature of my time in Chicago. My dad suggested I do it. She also insinuated I had my 11-year-old brother there for appearance.

Whatever. He was calling me every day saying he wanted to be on the show. He's 11; of course he did. *Her* brother came! I never said that to her. *It's the essence of hypocrisy.* She was so bitter it was ridiculous.

Keri could say I'm inexperienced, and I guess that's true, but I've been fortunate to know Nicole, and I'll take luck over experience. Keri should be so fortunate to find something half as great. If I'd dated every single chick in my city like Keri has in New Orleans, maybe I'd be more experienced. *Yeah, right.*

I have the feeling Cara wanted to make out with me; the feeling is not mutual.

Tonya: It was painful to watch Keri with Kyle. I'd say to her, "You're better than this. He's playing the game and you know it. *He's gonna hold your hand when the cameras aren't around and then not.*" When the cameras weren't there, Kyle would be very affectionate, but when the cameras came in he'd use the other girls as a decoy. He'd be all over me or Cara or Aneesa to act like that's how he was with *all* the girls.

There were times I'd get frustrated with Keri because I thought she related more to boys by being one of the boys. She thought she wasn't the girl men fell in love with. *She acted more like a tomboy.* In my opinion, she is a beautiful woman and she could probably make a man very happy.

Cara: I think Kyle had fun with Keri in the beginning, and then he realized she wasn't Nicole and got over it. Kyle is usually invincible, but he was really emotional in the beginning of the trip. He was really scattered and all over the place, and there was this pretty blonde he was super-attracted to.

Kyle and she fell really hard, and then Kyle fell out really fast and she didn't. I've never been in that situation, but it seemed awful. There's no more painful feeling than liking a guy who doesn't want you around, and Keri had to work and live with Kyle every day. That couldn't have been easy.

I wanted to say to her, *Play hard to get. She'd follow him around.* He'd go across the street for a sandwich and she'd frantically scramble to go with him. I was really

Cara: If Kyle thinks I want to sleep with him, well, come on, there are a lot of guys I want to sleep with. Don't flatter yourself.

surprised. I took her to be this strong woman, stubborn and cocky. I thought she was all so cool. To see it deteriorate was really surprising and really depressing.

It was hard for me because as Kyle realized he didn't like her so much, I realized I liked her more. *He'll admit he pursued Keri, but then he just stopped feeling anything.* That's rough. I think Keri and Kyle may be able to be friends some day, but I think it'll take some time.

When their thing was happening, I found it really annoying. I thought it was lame. I was like, *"Just have sex already."* She would have done it with him, totally. It was him. *Mr. Control.* He's got that type-A alpha-male firstborn mentality.

It panned out really impressively in the sense that I maintained good friendships with both Keri and Kyle. *There was never anything sexual between me and Kyle.* I would never want to upset Keri. I wish that she really understood that we were just friends. If I were her, I too would have thought the worst.

I think it was more of a risk that I was jealous of Keri than the other way around. Once upon a time, I would have absolutely resented Keri. She's beautiful and fun and

He's got that type-A alpha-male firstborn mentality.

Theo: I saw the initial attraction between Keri and Kyle kick off at a concert. It was a Moby/Outkast/Incubus concert. *I saw them kiss and stuff, it's their own personal business.* I don't know what else took place, but it was pretty conservative.

In the beginning, Keri was all Kyle and in the end she was all Keri. At first, Keri was strung out big-time on Kyle. She always had to be around him. Time went on and she decided she was going to have a good time when she could. She started meeting people and didn't let what Kyle had to say mess with her. *He acted funny when the first guy came around; he did seem a little jealous.*

As for Kyle, he came here, got into a situation with Keri, and then realized he had to get out of it. A lot of men—myself included—would have fallen to the temptation. *If it were me, I would've done something with Keri the first day.* Temptation is a bitch.

flirty and she got Kyle and passed the lifeguard test. *Five years ago, she would have put me in a panic.* But this time around I was like, "I love this girl, I want to be friends with her."

If it looks like Kyle, Keri, and I are a triangle, well, that's just not how it was. I hope Nicole doesn't buy into it and I hope Keri doesn't. *With Kyle, what I'm so excited about is having a real guy friend.* I mean, yeah, I was flirty with him at times, but it wasn't sexual. Yeah, at first, I had my feelings hurt that he picked Keri and not me. I guess I thought that since they matched us together at the train, that there would be sparks between us. It was just me being insecure, not me really liking him. *I guess I just wondered, "Why don't you want me?"* But, it's not like I was thinking, *I want you.* I swear I never kissed him. I wouldn't say I ever really wanted to kiss him. When I first met him, I thought he was such a stud, but I was not really that attracted to him.

Aneesa: I don't care about the whole Keri-Kyle situation. It doesn't mean crap to me. Two people were attracted to each other, but couldn't do much about it. Big deal. I think they missed out on stuff, because they wanted to be together. I really tried to distance myself from them, because it was so annoying.

Chris: I felt like I was in the middle of Keri and Kyle sometimes. During lifeguarding, they'd both take me aside and talk to me. It was like being inside a tennis match. *Their relationship agitated the entire house.* In the beginning they were together all the time. But Kyle is all about looking a certain way—for Nicole and for the cameras. When no one was around, he'd go and flirt with Keri, but then the minute the cameras showed up, he'd act like she'd instigated the whole thing. He'd complain to Cara, and bond with her about how Keri was after him. *He had this tight grip on Keri.* She didn't act perfectly, though. She'd drink and get crazily flirtatious. She could be overly aggressive. It wasn't nice to see.

Anthony Dominici: For our crew, following the beginning of a romance was fun. We all know what it's like to have those burgeoning feelings. They had a lot of fun together. *They bonded by quoting movie lines.* Keri's the biggest movie quoter in the world. They quoted *Austin Powers, Tommy Boy,* goofy stupid movies that I can't imagine people memorizing.

As they embarked on their romance, we had the sense that it was going to be a very long road for Kyle and Keri. *Kyle never really gave it his all.* He snapped out of it pretty quickly and started to pull back. It's tough when you see that.

I think that Kyle's dilemma about Nicole and Keri will be very relatable. Leaving an old girlfriend and an old life behind, and falling for someone else—people can understand that. In the end, Kyle chose Nicole. I hope it works for them. *He was definitely accused of being phony by Keri and to an extent he was.* He was doing damage control, so that Nicole would see he wasn't really into Keri. He made a clean and deliberate break from Keri, and was trying to save face. Kyle passed notes to other cast members telling them to please not talk about Nicole and to not talk about him and Keri as a couple. I think, in the end, he hurt Keri—not that she admits it, but I think he did. They had something kinda special and she's not at the point where she can admit that feelings she had were not returned, or that larger extenuating circumstances, namely the show, are why they didn't.

Kenny Hull, director: Kyle was vexed and Keri was put on hold. *In Keri's mind, she's not the kind of girl who's put on hold.* It made for an interesting mix.

Kyle & Nicole

Kyle: I had a lot of issues coming into the show, namely that Nicole wanted nothing to do with it. *I don't think The Real World is a very classy thing, and I'm the first to admit it.* Nicole has a serious job. I imagine the people she works with would think it was pretty trite, pretty superficial.

I didn't want to pull her into the show, but emotionally she was drawn to me. It was so mutual between us, the idea of keeping our interactions private. *We have a sacred connection.* I've had girlfriends, but I haven't had anything like I've had with her— I don't think most people have. I was very fortunate to find the love of my life at 20.

Seeing each other after getting off the plane was like coming home after being away for so long. It fit. It was so warm, and all I could think was I should have been there sooner. *Nicole is where I belong.* I'm not nervous about her watching the show, because of the understanding we have. Our love is such that anything that happens on the show won't break it.

Keri: I actually met Nicole in New York when the show was over. She is beautiful and adorable. When she met me, she gave me a huge hug and kiss. She's precious. *They're adorable together, sincere, and in love.* You can tell she's really independent and really in love. It was exactly what I expected.

I'm just really really nervous about her viewing the Keri stuff on the show. The truth is, Kyle did nothing wrong, they weren't together, he's 22. I really hope that it doesn't even temporarily ruin them. I told her, "You realize it might look like there's a love triangle between me, Keri, and Kyle." She told me she knew nothing happened. I think she's concerned she's going to go to work on Wednesdays and hear people say stuff about Kyle and Keri. *She's going to have to block that stuff out.* I don't blame her for caring, though.

Tonya & Justin

Tonya: I went to high school with Justin's sisters. He's five years older and all of the girls in my class had a crush on him. *Justin's kinda famous in Walla Walla.* His family is really rich and prestigious, they own all this property. Justin grew up in this huge incredible mansion. Their backyard looked like a park. They're all really good-looking and upstanding.

Keri: What's in Tonya's future? Many, many Justin babies.

Our first kiss was beyond incredible. We were in the park. It was just an awesome kiss. I had butterflies in my stomach times ten. I was so jazzed, but I was also scared. I'm not the kind of girl his family wants for him.

I didn't really meet him until I was in college. I worked at a tanning salon where he tanned. *He told the manager he thought I was hot.* Basically, that was how it started. We began lifting together. I didn't realize for a few weeks that he was the same Justin from back then.

We hung out as workout partners and friends. It was a difficult time for him, because his mom was really sick. *He had actually taken a semester off from school to be with her.* I knew I had to be a friend to him. I didn't want to be a girlfriend, because I thought his family would really resent me for taking him away from them.

Basically, we tried to just have fun together. Justin's a stud rock climber and we climbed together. *We didn't do solo dating for five or six months.* We just hung out. But it was getting harder to just keep it friends. We have so many common interests and little connections and this amazing chemistry. One time at the gym, I got enough guts to ask him what was up. He told me he was into me. We tried to stay friends, but it was really hard. I tried to not let myself fall in love with him. I didn't want to cross that line, but we did anyway.

During that time, I was Justin's refuge, a way for him to get away from his family. His sisters didn't take to me well. *They knew I was secretive and not very honest about my life.* They're from this upstanding family and they wanted him to be with someone they thought was good enough. The truth was, I had been lying to Justin about a lot of stuff. I wasn't at a point where I was very honest about my past. Lying had become a survival skill for me, and I was telling people my parents were dead. I wasn't ready to share my personal life with anybody and he was so vulnerable.

A couple of months later, his mom died. At the funeral his family didn't talk to me. Two days later, his dad told Justin that I wasn't good enough for him and that we should break up. *He told Justin that I was a liar.* Justin showed up at my house with this stone-cold look on his face and was like, "Tell me about your family." I admitted that I'd lied and tried to explain why. We both cried. He was like, "I still love you, I still believe in us, but we have to build our relationship and trust back and start from scratch." We broke up that night. His dad had told him it was Tonya or the family, and he felt like he wasn't going to lose his family for someone he didn't trust. *Justin left Walla Walla.*

I think it took losing Justin to realize that my lying hurt people. I started going to counseling. I stopped working out three times a day. I stopped trying to hide behind

my achievements. *I decided to just be me and let people accept me.* During that time, I started trying out for *The Real World.* I needed a ticket out of Walla Walla. I was dreaming about Justin every night.

About three or four months passed, and Justin called me out of the blue. He wanted to hang out again. All of a sudden, we were back. We decided to do it the right way this time. We started from scratch. It was difficult, but we both wanted it so badly. It was the first time I told somebody the truth about my life. It was incredible. To be truly honest with someone and tell him why I did the things I did, it was so much easier than lying. It made us feel embedded for life.

This is so pathetic, but when I found out I got on *The Real World,* my first reaction was to cry that I'd be separated from Justin, and that our simplicity—the simplicity of our love—wouldn't hold. I thought I might change, become part of the big city, and destroy everything we'd been working on.

Thank God that didn't happen. The second I got to Chicago, I realized that no guys could turn my head. *I realized I was so committed to Justin, he was the only guy for me.* I'm not going to lie. We'd go through phases when he'd tell me he wished I wouldn't go to bars or drink, but overall, he was really supportive of the whole crazy thing. He was just like, "Pursue **your** dreams." When I'd complain, he'd be like, "Be the woman I fell in love with. Get out there." It was so easy to be faithful. I didn't feel like I was missing out by not going out all night. I had something better at home and I just wanted to wait for it.

We talked about eloping the second the show was over. But once we got home, we were OK with taking a step back. We're moving in together and we've pretty much decided we're getting married over the summer. I don't have the ring on my finger yet, but we'll see. I'm not worried. *I know I'll marry Justin someday.*

Justin: I'm going to watch *The Real World.* It'll be fun to see the pieces I missed, to see Tonya interact with the roommates. *I'm not scared about what I'll see, though.* The only thing I'm worried about is taming her heat. I think I'll be dealing with her frustrations with how she's portrayed. But it'll be OK. What are you gonna do?

It will be hard to watch her butt heads with Theo. I think Theo said some things that were very out of line. It was good the world was watching, because, being in the relationship I'm in with Tonya, I might have done things to him that aren't socially acceptable. He said stuff you don't say to anyone, ever. Theo should be careful. He's going to get his a** kicked someday and I won't feel bad for him because he asks for it.

Tonya's and my future is bright and sunny. **We're going to be married this summer.** It's going to be really small. Tonya and I have been doing this alone and there are very few people we want to share this with. Maybe we'll invite people to the reception, including the *Real World* roommates, but I think the wedding ceremony will only be us. We're the only people who understand our relationship. We've come a long way, just the two of us.

Justin

GETTING MARRIED

Tonya: There was this whole thing about whether Justin would propose to me on TV. We used to talk all the time on the phone about getting married. Well, production listened to our phone conversations. So in interviews, they asked me whether I thought Justin was going to propose. I think they asked all the roommates that, too. So, when Justin arrived, everyone was buzzing around him, asking when he was going to do it. Cara made a snide comment to him about how she was expecting him to pop out a ring. He got all pissed and shocked. That actually made me mad at him. I was like, "Look, you're the one who talks about marriage all the time. If you don't mean it, don't talk about it." Justin never planned on asking me to get married on national television. I'm glad he didn't. That's a very private thing.

Cara: At first I was nervous that Tonya was more into Justin than he was into her. But then I realized that he was just as grossly into her. I'll be really curious to hear their phone conversations on TV. I was always wondering whether she showed him the side she showed us, the not-so-charming side. *Seriously, I can't imagine why he puts up with it.*

Kyle: How Tonya acts with Justin is sixth grade. Watching her was unbelievable. If he has a change of heart, I'll be very worried for her. *She's got her present, past, and future wrapped up in him.* She doesn't have a family; everything is Justin. It makes sense. But it's not so easy to live with.

Chris: In the beginning, I thought Tonya and Justin's relationship was weirdly codependent. *But I realized they're sweet and nice together.* They love each other. Justin's a total sweetheart and I hope Tonya holds on to him.

Aneesa: Tonya and Justin were cute. They're really different. Justin's intelligent and humble and sweet and funny. Tonya's not the smartest girl I've ever met. That's just reality. And she's not funny. They're two very different people. They've only been together seven months—you'd think they were together for years how she talked about him.

Anthony Dominici: I think Tonya used Justin as an escape from the house, like Kelley from New Orleans who checked out with Peter, her boyfriend. When we cast Tonya, she wasn't with Justin and that was two weeks before the show. *We thought we were casting a more independent person.* Justin was her safety net when she was in Chicago. No one could have been more supportive and more there for her. He's a good guy. He was pretty straight-up. You have to commend him for that. He didn't apply to be on the show, Tonya did.

Lisa: *I had a really weird sexual dream about Tonya once.* She held me at gunpoint and was really aggressive. I woke up and was like, *Whoa.*

Cara's Dating Life

Cara: I know I didn't do anything wrong in Chicago. *I'm 22, I'm single, attractive, and comfortable being a sexual being.* So I dated a bunch of people.

I know what it's going to look like, like there's a revolving door in my bedroom. I've got a grandmother and a 14-year-old sister and I don't want them to see that. I want to say, *Barrie, don't be like me, don't do it.* It's a battle. Here I am saying I'm comfortable in my sexuality, but I'm not comfortable with the stigmas attached to sleeping around. *I've got a daddy and I mean daddy as in D-A-D-D-Y.*

I'd love for it to be out there that I'm more talk than action. *I can be just as prudish as promiscuous.* I don't know why I keep using the word *promiscuous.* It's a messed-up word. If I were a guy, I wouldn't feel this way at all. It would just be normal to have slept with as many people as I did—which really isn't that many. My worst nightmare is looking like a Samantha in *Sex and the City* slut.

Tonya was always condemning me. I asked her: *If you weren't with Justin, wouldn't you do the same thing?* She told me she'd never have sex in this house, like it was the worst thing to do. *She also thinks it's not appropriate to talk about sex.*

According to Tonya, you can have it, but not talk about it. Aneesa was with a bunch of people too. I adore her and I'm glad we're going to be dealing with this together, though she's definitely not as worried about it as I am.

Cara and Jared

Cara: Jared and I rolled in similar circles during college. *We were friends for years before we went out.* The truth is, I thought he was sleazy, and he thought I was a slut—we joked about that all the time. At first, when we started dating, everyone was like Jared and Cara, huh? It was big news at Wash U. We don't seem like we should be together, but then, once you think about it, it makes perfect sense.

Our first date was a double date with my parents. My parents were going to a Cardinals game and they asked me to bring a friend. I just ended up asking Jared. *I didn't think anything of it; it was really casual how it happened.* Then, the next day, I was all butterflies.

I couldn't figure out why. When Jared came over that night, I wasn't there to answer the door. I was with my sister doing her hair. Unbeknownst to us, he'd gotten into the house and was hanging out with our parents. When we found him, he was sitting on their bed, laughing with them. I was like, "How'd he get in the house? How'd he get into my parents' room?" He was so comfortable, and it was nice. *It was like he belonged in my family.*

We had this great time at the game. He thought it was really sexy that I was drinking a Bud and eating a hot dog. We went to the smoking section to take a break and we kissed our first kiss. *We were like, "Are you feeling this?"* We were together for the next year.

During that year, I remember writing in my journal: *I love Jared, this is amazing, but is this the be-all and end-all of love?* I thought, *If this is it, that's all right.* But I had the sense there might be more. I had had my heart broken for the first time at that point. My heart was shattered by Ali. There was always the fear in Jared's mind that I still had feelings for Ali. As time had proved, he wasn't far off. *But I didn't break up with him because of Ali—*

or The Real World. I broke up with Jared before I even knew I was going to be on *The Real World.* I still don't really know why I broke up with him. He wanted concrete reasons, but I didn't know why.

There was just something, I don't know what. He's amazing, he's awesome. *I guess I just wish I'd met him later.*

On our trip to St. Louis, I spent every night with Jared. We slept together, but we didn't sleep together. We kissed and made out and cuddled and, to me, it felt like good-bye. It was so natural, it was almost painfully comfortable. I had "my pillow" and my space in the bed, but I guess I'd moved on.

Cara and Ali

Cara: Ali has always had this power over me. He has this way of manipulating everybody, but me in particular. We were together for a year and we had fun, but a lot of it was partying really hard. When we were going out, it was like the more he pushed me away, the more I got into it. *I'm too weak to him.* Behind closed doors, he could be a sweetheart. He was in love with me too. He would say "I love you." But it was never enough. I can't see him now. It sounds a little bit unlike me and also kind of angry and disturbed, but I feel like I have a

little of the power back—it's both exhilarating and liberating. The truth is, he and I have a really good time together. *Maybe we can be friends, once we get over the attraction.*

I regret doing anything sexual in the house. It's going to look like I'm a slut, and I'm not. I'm more a prude than anyone would know. I dated four guys, and it's going to look like more. Our job as cast members was to give 100% and I feel like it's going to backfire on me. I gave 100% of myself, and I'm going to look bad for it. My reality is *not* being like this.

Cara and Djordje

Cara: What's there to say about Djordje, Kyle's football buddy? I just thought he was adorable. I thought he was really cute. *It was the first real one-night stand I ever had.* In truth, it turned out to be more because we saw each other again. I don't know if it's going to be on the show that he came back to visit. But he did. We spent another couple of days together and were e-mailing.

He freaked out because of the cameras and ran. The audience is going to think he ran 'cause of me, but it was really the

cameras. He was terrified of the cameras and what his family might see—he's from a very strict family. I was freaking out when he didn't call, but I knew the real reason he was freaked.

I guess you could say I have a thing for foreign men. I don't know why, but I really do. I love them.

Cara and Nick

Cara: I think Nick's cute. In the beginning of my time in Chicago, I wanted that Wash U. connection. He's a sweetheart, he's funny. **The *Real World* thing made him pretty uncomfortable.** But it was much more appealing to have a guy be uncomfortable with the cameras than turned on by them. 'Cause then you knew it was legitimate.

Cara and The Rock Star

Cara: I can't believe that's gonna make it in the show. I grew up listening to that band!

Here's what happened. Keri and I pushed our way backstage. It was the one time I got into using my *Real World* status. I just thought the lead singer was really dreamy. *I set my sights and thought, Dude, I'm gonna make this happen.* Keri was really encouraging. She pushed me to invite him where we were going. There were so many

girls waiting to meet him, but I called him over and he looked at me—the cameras were not around us—he was like, "Hold on, I'll be right back." Keri and I invited him out. I was like a vixen. It was totally his voice that I was into. I got really drunk because I was really nervous. We went up to his hotel room. *I made him sing to me, and we didn't sleep together, but we hooked up.* I left the next morning with a horrible hangover. He promised he'd be in touch, and that was it.

I'm embarrassed for him to see it. I doubt I'll ever see him again. For the rest of the time in Chicago, Kyle would joke, saying "The rock star is on the phone!" or *"Cara, Bruce Springsteen called."*

Aneesa: Cara's never been single. I don't have a problem with her dating people. It might hurt her image a little bit, but you know, whatever makes her happy makes me happy. Some of those guys are cool, but they don't measure up to her person. *I'm sure she wanted to feel loved and be held.* That's how I feel sometimes. I'm in no position to judge her or anyone.

Chris: I think Cara's going to get hurt watching the show. If that relationship with Jared was so strong, then she should feel devastated by her actions in Chicago. I think it's warped and twisted that she had to seek out men to make her feel right. I've been where she is. *I think she was looking sexually to escape.* If she wants to change that behavior, then all the power to her.

Keri: This was the first time Cara was single and she learned so much going out with guys and having fun and being 22. So what if she shagged some people?

I liked some of the guys she saw. One of them, Nick, was a bore. He didn't have that much of a personality. I didn't like Ali and couldn't believe she still talked to him after he'd cheated on her. But she got a little revenge. *She used him a little bit, I think.* When he came into town, she was sweet to him and then told him to shove off. I like that.

Jared was so cool, awesome. They have the right idea when it comes to a relationship. She watched his feelings and had so much respect for him. If they're meant to be, then one day they will be. That's all you can ask for. *Kyle needs to keep that in mind with Nicole.*

Tonya: Watching Cara be promiscuous was difficult. Occasionally I'd see Cara feeling kind of empty the day after. She went a little wild for a while. *I agree that it's esteem boosting to get attention from men and then tell them to screw off.* I could see Cara doing that. She constantly needs male attention. She'd be like, "I hope you don't judge me." I was like, "Look, I've been where you are, but it doesn't work for me. I've had one-nighters and felt like s**t and I can't do it anymore." I'd tell her

to be careful about her image, to keep in mind how she'd be portrayed. We have very different beliefs about how you're supposed to act on the first date.

Theo: What Cara did was Cara's business. I told her from jump that it wasn't a good idea. *I told her, "I watch the show, I know the angles it takes."* That's why I protected myself. I was with several women the camera missed. The cameras can show me out with women, dancing, maybe kissing, but they can't show me with them in bed. I knew about the bedroom cams, and I warned everyone else. I told Cara, "You give 'em the whole thing, and trust me they're going to use it." She asked me if I thought she was going to look bad. I said yes.

I don't know how many men there were. It was kind of bad to live with Cara and see it. This guy, this guy, and this guy. Jared is a dynamic guy. I don't have one bad thing to say about him. *What he's going to see on TV is going to hurt him.* All his friends are gonna see Cara in bed with a bunch of dudes. She's better than that, she's so much better than that.

*Chris's hand on Cara's a**.*

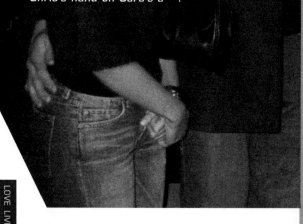

Cara and Chris: Secret Kiss

Cara: Off-camera, Chris and I kissed once. We were at Buckingham Fountain taking pictures. *We were really getting along that day.* The sun was shining, the fountain was behind us. I was barefoot and wearing this great Neiman's outfit. And he was in a fancy suit. We were sitting at the fountain and we just kissed. It was a nice kiss, a soft, flirty, friendship kiss. Aneesa came up and was like, "What the f**k?" She interrupted us. I told Tonya and she was really freaked out by it. There were no cameras and I was never asked about it.

Chris: I still have girlfriends I cuddle and am kissy with, but nothing beyond that. That said, there was always a sexual tension between me and Cara. *Yes, we did have a cute little intimate moment.* She leaned over and kissed me and it was cute. It was a short peck totally provoked by her. It was Cara freely expressing her attraction. What was I going to do? I couldn't resist.

Theo & Aneesa: Crush

Theo: Nothing happened ever. Really. But I tried. The second night, we were sleeping in the same bed. *She was fast asleep and I started kissing on her back and neck.* I didn't start feeling on her. I was hoping she'd wake up but she was knocked out solid. The next day, I apologized to her that I tried to kiss on her and I hoped she didn't feel violated. She was like, "I can't believe you." But then she told me not to worry.

When Aneesa got into the shower with me, that was the moment when we were breaking into being friends. I was truly attracted, but I was more in awe—like, *This girl done and gotten in the shower with me.* I think that was a test for her to see what I was really like. I realized then that she's someone I can feel comfortable with, friend for life, sister.

Chris & Kurt

Chris: My relationship with Kurt was exciting and fun. He's a very smart, intelligent, hot guy. He's 32, which I think is a perfect age for me. Kurt had a fun side to him. He's a great conversationalist. *He's really in touch with his emotions.* I loved his athletic drive.

It was tough for me to meet someone for the first time with cameras there. The cameras are a constant reminder of the fact that you're miked and you're being filmed. There are some things that you hold back and don't talk about because cameras are there, and that's a difficult thing when you're beginning a relationship.

We didn't have sex. We spent the night together in Lake Geneva, but we never really got together. That was where both of us are at. *AA recommends that you don't have relationships in the beginning and I took that to heart.*

I've had many boyfriends, and girlfriends for that matter. I've gone through a cycle of finding people to make me feel whole. *In that process, it's easy to lose yourself.* Right now, I'm trying to get to know me. Kurt could be a little smothering. He wanted to get married. That was just what happened with my last boyfriend—he wanted to get super serious within a month.

Kurt's a great guy and a total sweetheart. I got a good friend out of the deal.

Aneesa's Dating Life

Veronica

Aneesa: I met Veronica and was immediately attracted to her. We were at this club called Red Dog. She's not the prettiest girl I've ever dated, but I liked the fact that she was mixed and spoke Spanish and was feminine. She didn't have much personality either, but there was something about the mix—me and her—that worked.

We went out to breakfast. ***She told me she'd just broken up with her girlfriend.*** I thought I was dealing with a single person. That morning, she called me and told me she'd had a great time. ***Well, I was flattered.*** We started hanging out some more—going to clubs, eating, regular stuff. In fact, the next night, we went out to dinner at a Thai place and it was just really fun.

Here's when the bad stuff happened. This wasn't on camera. I'd called Veronica's house. I was sitting in the car with Chris and some of his friends and this girl Star-69's me. It's Veronica's ex. She's cursing at me insanely. This woman's 30 and has an 8-year-old son, you'd think she'd have more respect. Anyway, we did a lot of s**t-talking. She told me to come and meet her in front of the house and we'd fight it out. I'm not a violent person. I'd never do that.

The next day was Market Days. ***I see Veronica and she has about ten million hickeys.*** I was like, "Did you sleep with your ex last night?" She admitted it. I was like, "Well, don't kiss me then." We still hung out, I just wouldn't let her kiss me. She slept over at the house. And the next day we went back to the festival together. Veronica warned me that we were going to run into her ex, which we did, and it turned into a major scene.

I told Veronica I wouldn't play second fiddle. I was upset. **She'd spent the night with me the night before, and she just wasn't broken up with her girlfriend.** I wanted to forget the whole thing, but of course, that's when she showed up at the door. Now, I know this is going to be this big major deal on television, so let me spell out exactly what happened.

I was at home, hanging out. I was in a towel, smoking a cigarette, when Veronica starts ringing up to come in. **I look in the security camera and I see that there's a girl in a tank top behind her.** I couldn't believe it. So, I changed my clothes, and waited for them to come up. It took like ten minutes.

The minute they entered the house, I started yelling at them. I had Chris and his friends with me. I was like, "I can't believe you would disrespect me like this." I was screaming at Veronica, but talking st to her girlfriend. I could have acted more maturely, I know. I'm just glad I didn't physically hurt one of them. What would that have gotten me? A lawsuit.**

I threw Veronica's bag at her face and slammed the door. I closed my hand in the door, and I swear I still have a bruise. **Then, I ran down these steps we're not supposed to use, my roommates tearing after me, screaming, screaming.** I was out of my mind. I even left a lit cigarette in the house.

When they left, I called my mom. I was crying. I was so mad at myself. I do have a bad temper and say things I don't mean, and that's a flaw. But that was really wild. I am not a raging animal. That is not who Aneesa is. I called my mom for sympathy and she wouldn't give it to me. I guess she was still pissed at me. See, before I left for Chicago, I spent all the time celebrating with my friends, and ignored her. So, she was holding a grudge. **Overall, that was a sad and embarrassing night.**

That next Wednesday, Veronica paged me ten times. She was crying and apologizing and begging me to meet her. I did. I told her, "If I take you back as a friend and a lover, you still won't have my heart. I let you have a small piece, and you stepped on it; you lost your chance and I don't trust you."

I am not a raging animal. That is not who Aneesa is.

I never slept with her again. We had a mutual friend and we hung out sometimes, but we were never all buddy-buddy lovey-lovey. She's a weak person. She called me crying about the ex two months later. I told her that if someone loves you, they're not going to hurt you. I have to think about that for myself, though. *If she liked me, she wouldn't have done that to me.* I let her make me feel like s**t. I allowed myself to feel all this pain and hurt for no reason. I should have walked it off.

The whole thing was ten times worse knowing that millions of people were going to watch it. I don't want people to see me as someone who got played. I learned I can't trust everyone. I can't be so naive. I need to look at situations for what they are and not what they potentially could be.

That was definitely the worst thing I was involved in, but look, you can't dwell on this stuff. It's a part of life. *I can't be mad at myself for that forever.* I know people are going to see it and think I'm weak and I

was played, but what can you do? Oh well. It happened. Move on.

Theo: Veronica was terrible to Aneesa. I wanted to smack her when she brought her ex-girlfriend through the house and made my girl look stupid. *She didn't deserve a second of Aneesa's time.*

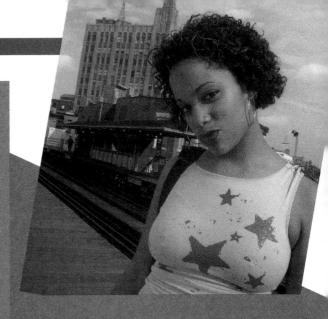

Veronica did what she did for show. She likes drama. I give her kudos for that. She wanted to be on television. That's just how people are. When it airs, she's going to be like, "Check out *The Real World*."

I told Aneesa: 1. You should have never let her up, 'cause you look dumb as hell. 2. You shouldn't have been in her girlfriend's face, you should have been in Veronica's face. I think it was just lust. *Aneesa gives her heart and emotions too quickly.*

Chris: Aneesa gets into conflicts with whomever it is she's dating. She'll do just fine as long as she grows up a little bit in terms of dating. She does something I used to do: search for someone to make her right as opposed to working on herself and making herself right for someone else. *In time, she'll really know what she wants in a relationship.*

Danielle

Aneesa: Danielle's my sweetheart. There's not that much to say about her. *I was wildly attracted to her, oh my God, yeah.* We were monogamous. I mean, I was friends with Latonya at the same time, but we didn't really do anything. Danielle and I dated exclusively for three and a half months. Most of my time in Chicago, I was with her. We had our share of arguments, but it wasn't that serious. We didn't listen to each other well. She had a bad attitude. I don't know, sometimes we just came at each other wrong. We broke up about a week before the show ended. We're friends now. We're talking.

Theo: Aneesa liked Danielle a lot and that was what was important to me. When Danielle came around, it was cool. She and I actually got along. Other roommates thought she was rude, but they just didn't understand the relationship Aneesa had with her. They cursed each other out all the time. *That was just how they acted.*

Keri: Aneesa seems like such a strong person, but these girls come in and treat her like crap. Veronica, Danielle—Aneesa would cry about them all the time. *It was rough to see, but she's gotta go through that stuff like the rest of us.* I thought Aneesa's fight with Veronica was fantastic.

I know people are going to see it and think I'm weak and I was played...

Chris: There was a point when Tonya pissed me off so much. The hours between 10 and 12 at night were reserved for Tonya and the telephone. It was never something the roommates decided, it was just how it happened. We took it for granted. Well, off camera, Tonya and I got into this huge fight. I wanted the phone and she was on it and I flipped out. I was like, "Why don't you feel bad about monopolizing the phone?" I completely lost it. I had to call my mother. She *had* to talk to Justin. I think that just points to how she didn't have two feet planted in Chicago.

Tonya & Theo

The glass

Tonya: That evening, Theo came home pretty loaded. Every time he drank, he got temperamental. Anyway, he really needed the phone. He came up to me and was like, "Gimme the f'in phone."

He hung up the phone on me. I said, "You wouldn't do this to Kyle." He called me a bitch and I threw the wine glass. I'm not forgiving to men who frighten me. He intimidated me, he scared me. Throwing the glass wasn't me threatening him, it was me just doing whatever I could to get him outta my face.

I actually threw the glass away from him. I wanted him to back up. In my head, I was thinking, *Just because I'm on* The Real World *doesn't mean I have to live like this. I wouldn't put up with this in my real life, so why should I put up with it in my TV life?*

The house was pissed at him. He came back and tried to apologize, but I thought he was full of crap. If your dad's a pastor, you know how to treat women. After that, he really did try hard to make amends, but it was pretty much done. I forgave him enough to deal with him.

Theo: Tonya throwing a glass was one of the stupidest things I've ever seen. She could have cut Aneesa's leg, anything could have happened. That was an ignorant-a** move. That whole argument could have never taken place if she hadn't been so ignorant. I had to make a phone call that literally would have taken a second—just to see if my ride was there. I said, "Tonya, please sweetheart, can I have the phone for one minute." She kept saying no. I called her a

bitch. She came up to me, and she and I were spittin' in each other's faces. She told all the girls I was the one who got up in her face. She said, "I'm so scared of Theo," and a whole bunch of other bull. Since the beginning, she wanted my roommates to think I was some crazy black guy. Yeah, right, everybody got love for me and no one likes her. How come that?

Aneesa: Ooh, the glass! You mean, the one Tonya chucked in my face? OK, that's not exactly true, but she did almost hit me. Theo hung up the phone on her, and she chucked the glass. It landed in our room, and crashed in a million pieces. She was sitting on the floor, I was hugging her, and I felt bad for her, but crap happens sometimes. Granted, Theo did not have to hang up the phone on her, but Tonya likes to play the victim a lot of the time.

Cara: After Tonya threw the glass, I held her. She was crying. "He scared me. He scared me. He scared me." Yeah, he was being crazy, but regardless, she's scared of black men.

Kyle: Tonya felt threatened in the house. I can't live in a house where a woman feels threatened by another man and do nothing. Theo's and my half-hour talk set the tone for the rest of our relationship. We had a man-to-man talk where I told him I didn't like what he was doing. I was looking out for him as much as I was for her. I didn't want him to be labeled as a chauvinist or a wife beater. Our blood was definitely flowing, but it could have been much worse. I think our relationship could have gone sour at that point. But our relationship was smooth sailing after that. That's how I like to deal with things.

chris's sobriety

Chris When I started casting for *The Real World*, I'd been sober two and a half months. I've learned so much about my alcoholism since then. I've gone to so many meetings, gotten so much stronger. When I got to Chicago, I didn't even know myself.

Within the first two days of being in the house, Kyle put me on the spot about my alcoholism. Of course, I wanted to help and share my answers with him. But I didn't know that much about it at the time. I've learned so much since then.

I was never a daily drinker. I would drink every night and on the weekends; Sunday brunch would be mimosas and then maybe a couple of beers. It went from drinking occasionally to binge drinking to not having control and waking up the next day with a hangover. I made all these stupid decisions when I was drunk. I drank because I didn't want to experience the fear I felt as a sober person.

One drink would turn me into a different person. One drink would fill a hole in the pit of my stomach, the part of my soul that wasn't open. I would have blackouts, I would forget where I was the night before or who I was with. I would drive drunk and not remember where I'd parked. That's scary. People die like that. I used to think that only winos and homeless people were alcoholics. Guess I was wrong.

I know today, after having gone through the *Real World* experience, that I'm strong. I am so grateful to have a clear mind. I didn't want to drink on the show once. Seeing my roommates drunk didn't repulse me, but I learned from it. I was exactly like that at one point.

I thank God that I no longer have to live with the awful hangovers, that I no longer have to spend all that money on alcohol. I'm so very grateful that's no longer me.

The van

Tonya: When Theo was late for work and we almost left in the van, he was swearing at us like nobody's business. He was calling me every name in the book and spraying spit at me. Justin told him what he thought of him and his behavior toward me. Theo's gonna get himself in big trouble someday.

Theo: I waited until the cameras went off to apologize to Tonya about the van incident. I said to her, "I don't want you to think that was a personal thing between us. You pressed my button and I apologize. Please know I didn't do it to personally hurt you."

I did that because I didn't want it to seem like a fake for the cameras. I wanted her to know that I was dead serious. She knew how I felt, and that's what was important.

I come out on top regardless.

Tonya: getting sick

I was quite the piece of work on national television, huh? Before I left Walla Walla for Chicago, I was suffering from chronic bladder infections. They were turning into kidney infections. I was on IV antibiotics before I left. I had to go to the hospital every twelve hours. The doctors couldn't make sense of all my problems. I had back pain, kidney pain, I was peeing blood and passing stones.

Even though I was sick, I never thought about not going to Chicago. For some reason, I was under the impression that I would be covered by health insurance when I was doing *The Real World*. We have one specialist in Walla Walla, and I was psyched to think I'd have all these good doctors at my disposal in a bigger city.

I was sick the second I got to Chicago. I knew I had to go to a doctor. I told production, but they couldn't help me. They said I had to deal with it on my own. Well, I was scared. I was in a new environment. I was peeing blood. A couple of weeks into the show, I passed a kidney stone in the Real World bathroom. It's the most painful thing ever. I couldn't move. I felt like I was going to die. You bet I saved the stone. I got a cup and put it in it and showed my roommates. I was like, "You think I'm a wimp. This is what I'm peeing." It was pretty big, like a dime.

I'm a really controlling person, and in Chicago I often felt out of control. When you have kidney infections, they load you up with pain medicine. That's why I acted so weird all the time. I'd get nervous and feel distrustful and uncomfortable. Going to the doctor is hard for me because it makes me feel very alone. I was erratic, behavior-wise. At first I was secretive. I didn't tell production everything. I was thinking I had cancer. Silently, I was freaked out. Peeing blood all the time is not normal. God, I was a wreck.

A week after I passed the stone, I was in the hospital. I don't think I've ever been that sick in my life, and here I was being filmed for national television. My roommates were really there for me. They took photos with my kidney stone and they really lightened up the mood in the hospital room. My roommates saw me sick and scared and insecure.

I always felt like I had to defend myself. I felt like everyone thought I was pretending. It was a double-edged thing where I both wanted people to see how sick I was and to run away from the camera. Who wants the world to see you rolling around and throwing up and looking how I looked?

Anthony Dominici: When Tonya was sick, she wasn't the most honest with production. She didn't let us know how sick she really was. It was frustrating as a producer because I wanted to know that everyone was OK. When Tonya went to Walla Walla, I did not think she was going to come back. I'm proud of her for sticking it out.

I really hit rock bottom. I would crash and burn.

The doctors figured out that my stones were carrying an infection. I was on all these medicines which had awful side effects—like turning yellow. Yes, that's on national television. Then they told me they were going to do a test for cancer. I was freaked out. What if they find something? I did *not* want that on television. I was being cagey, I admit it. I wanted to be in control if something really bad was going to happen. I didn't want to have cameras with me if I got bad news.

My not going on the trip was this huge controversy in the house. They thought I wasn't going just 'cause Justin was coming, but I knew the truth: the doctor told me I was too sick to come. Plus, I was having this surgery. At that point, I didn't care what my roommates thought and I didn't care what production thought. I was just so sick and trying to get through the show.

I really hit rock bottom. I would crash and burn. Sometimes I'd be up and sometimes I'd be down. It was really hard for everyone to understand. I know as a nursing student that you only pee blood for a couple of reasons. I knew it was serious. The surgery got to the source of the problem. It ended up I had fibrous cysts on my cervix. But had those infections not been cleared I would have gone into renal failure.

After surgery, I started coming back. I've had one bladder infection since I've been home. I guess I'm prone to them. I realize I used to have them growing up, but my foster parents didn't take care of them. If you have untreated infections, stones are created.

My roommates had to be patient with me and I was not the nicest person to be around. They were tough and patient and for that I'm thankful. But it will not be easy to see the whole story play out on TV.

Kyle: There was a period when I thought Tonya was going to go home. I thought that very clearly, I really did. Maybe it was wishful thinking.

She knew that we wanted her to leave. At one point when we were hanging out at the office, she made a little speech about how she was feeling better. She ended the speech by going, "Nice *try*," implying that we had been trying to get her to go.

I was like, What the hell does that mean? She thought certain people were trying to get her to leave, and I think she mainly meant Aneesa. There was a crazy dynamic between them. Not even just fights, but little things. Aneesa was seriously skeptical. She'd go on the Internet and investigate kidney stones. I thought it made Aneesa look like a horse's a**. To look like you don't believe someone's illness. There was nobody in the house who wasn't skeptical at all, but to spend your time on the Internet cross-referencing!

Cara's relationship with Tonya was markedly different from the rest of ours. They lived together in the same room and Cara was the mother of the house. She used to say

she was the mother and I was the father and Tonya needed looking after. When you walked into the room when Tonya was sick, it was such a negative vibe. Cara used to come into our bedroom and be like, "I don't want to go into our room, it sucks the life out of me, it's so depressing." At 10 Tonya would have the lights off with her eye mask on. Cara is all light and sunshine, the opposite of that. Sunshine and rain on either side of the room.

Cara: It was hard for me to hear Aneesa and others say that Tonya's story didn't make sense and that it was exaggerated. I didn't care. I was going to trust what she was telling me. I don't think she's a liar, but I think she's got a lot of problems. I think some of her illness might have been upstairs, but I don't blame her for that or discount how badly she felt.

Theo: Tonya went through a lot of pain. I commend her that she went through *The Real World* even though she hated being sick on camera. I went to the hospital and there were no cameras. We sat for a few hours. That was when we weren't getting along. I wanted to show her that I might not like her, but I had love for her. She needed to know that despite our fussing and fighting, I was still there for her.

At times I thought maybe her illness wasn't as hard as it seems. I don't know if she faked it, but she'd go work out instead of go to work and that leads you to wonder. Her priorities weren't in order. She wouldn't go to our job, but she'd go to her dumb waitressing job.

When she's ill, she's a total bitch. Capital B. One hundred and ten percent.

Aneesa: I was coming out of an interview, and I ran into Tonya's friends from home who were visiting. We went to Starbucks. They told me she had sex with Justin when she was still really sick. I think that made her even sicker. I did some second-guessing of her illness, yeah. I'm not a stupid girl.

I found it kind of intriguing. It's not like I wanted to prove her wrong, I just wanted to test her sometimes. No one will ever know if she was really sick. Any of us could have come in there and lied about our entire lives. Everything she told us could be a giant lie.

I think Tonya thought she was sicker than she was. If she was so sick, be in bed. If you can go out, then you can go to work. If I had missed as many days of work as she had, I would have gotten fired.

Justin: It was really hard to be away from Tonya when she was sick. That was the hardest part of being away from her. It was so difficult to know what was happening. Tonya deals with medical problems by not telling people about them. It's hard to know what's really happening and it was even harder being separated from her. I was calling doctors and getting medical records together. It was hard on me.

If her roommates didn't really believe it, well, all I can say is: believe it. She's tough and she pushes herself to the breaking point both physically and emotionally. The problem wasn't getting fixed, but she'd push herself. Being active and busy is essential to her emotional and mental success. If she's not busy, she's upset. When everything's good physically, she's got energy galore.

Chris: The house called into question Tonya's sickness. I regret that. In these reality TV shows, that's what people do: they gossip, they make fun of each other. Well, we indulged in that and it was wrong.

She could be very draining, and all about Tonya and her sickness. That said, spiritually I did some things I'm not proud of. I poked fun at Tonya and talked behind her back. I regret it. I speculated about her not coming on vacation with us. I feel bad about that. We all did it. Cara would come back from the hospital and start talking crap, be like, "Oh, my God, what I just had to do!"

Now, I think whatever Tonya needed to do to get through that time was OK. I think she was in a state of depression for much of the show. She lived in that bedroom, but she wasn't really there.

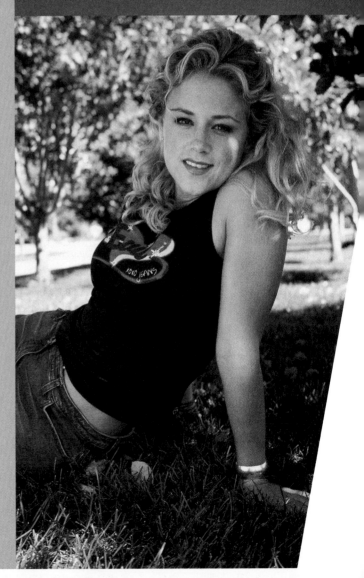

The vanities

Aneesa: Cara was definitely the vainest person in the house. She'd pluck her eyebrows in the confessional. She was just very, very concerned with her appearance. She'd be in the mirror all the time.

Kyle: Chris was so very into his appearance. He was always checking himself out.

Keri: The vainest person? I don't know. Toph looked at himself a lot. Probably it was Tonya. She always talked about her body and how perfect it was. Theo said I was the hottest? Well, he's my sexy brother from another mother. I absolutely love Theo.

Chris: I admit it, I'm a little obsessive. Yeah, I check out my body in the mirror. But, let me tell you, there were no good mirrors in the house. They were for short people. I want to make sure I look good at all times. It doesn't rule my life, though. It's not like I live for a bikini wax and a manicure and pedicure.

cara was definitely
the vainest person
in the house.

TANNING

Cara: Tanning is one of the grossest, most narcissistic habits I have. I've been tanning since I was 16 or 17. I love the sun and I love being tan. In Chicago, I did it because it was time on your own without the camera crews. You're in a coffin listening to music. There are studies that say light therapy is good for you, and I believe it. Tonya would go every other day. Keri, Chris, Aneesa, and I would go every now and then. I probably went once a month, maybe more. I'm trying to wean myself off the tanning bed, it's so gross and so horrible for you.

Chris: Yes, I go to tanning places. I try to maintain a healthy glow. I went once or twice a week.

The Pinch

Cara: When Chris pinched me, I panicked. He's all OCD about body stuff, and I knew what he was thinking: I'd gained weight. I saw it as an act of cruelty, not an act of love. If someone did that to him, he'd flip out. I guess I was really wound up that day. My two sisters—Tiny and Tinier—were coming over, and I just needed to let it all out. I needed a good cry. I'm probably 105 pounds now. I think I was a lot less, maybe 100, coming into the show. During casting, my metabolism was ridiculous, I had so much nervous energy. I know I'm still tiny. But it's difficult for me. All the roommates tell me I have a butt now, that I have curves. In my head I'm thinking, *I do? They see it? Do they think it's bad? IS it bad?*

Chris: Cara was walking around in her black leather pants looking really sexy. I pulled her hips to me and said, "You sexy thing." She looked at me like I'd punched her in the face. When she started crying, I thought she was kidding. Keri told me, "Don't worry. She's an actress." But she was serious. I felt bad for a minute but then I realized, *Hey, I didn't really do anything to deserve this.* If someone did that to me, I wouldn't care. Would I scream and cry? No. The girl's a stick. I grabbed Aneesa all the time and it was only affectionate.

Aneesa: Cara was fine with the eating. Tonya was the one to worry about. She lost eleven pounds when we went on our trip. She'd make a big deal about it, like "Look how big my pants are." We'd all be like, *Shut up*—at least in our heads. I love my Cara. She ate very healthy. She's just a little person. Her sisters are tiny too.

When Cara was crying about the pinch, I got pissed at her. She probably weighs fifty pounds less than me! I was thinking, *C'mon, you weigh ninety-seven pounds.* I was the chubby girl when I was little. I know what it really feels like to be fat. I was the biggest girl in the house, and let me say for the record, I'm smaller than I look on TV.

Tonya: My eating problems started when I was in high school. People would tell me I was beautiful and stunning and the better I looked on the outside, the less people would judge me—at least that's what I thought. A year ago, I was 97 pounds. I'm 115 now.

I feel like I'm doing really well with it. I related to Cara and her body image problems, but sometimes she didn't want to deal with them.

Aneesa: Tonya thinks she's so hot. She says so *all the time*. I think she's trying to convince herself of it. It's so annoying. Shut up! I don't think she's hot! Actually, I don't think she's hot at all. I really don't care. Tonya told me about her t**s the first day, but I'm sure I would have figured it out. No one's t**s look like that.

Cara: Tonya and I had a trust. We could say anything to each other. That got violated. As an example: In the privacy of our room, we talked about the eating issues we both had. I never had a real eating disorder, but I definitely was pretty obsessive. Tonya

told me about her plastic surgery. I thought it was cool. My grandfather's a plastic surgeon. I see nothing wrong with it. Then, when she figured out that everyone in the house knew about her boob job, she blamed me. She thought I'd been the one to tell everyone about it. Quite the contrary. I never told anyone. I may not have denied it when people asked me about it. But, as I said, I would have supported it and said, "What's the big deal?" I mean, it's pretty obvious. Her boobs float in the Jacuzzi. I think they're beautiful, they're a good job, what's the big deal?

Out of anger, Tonya once said to me: "I told you about my boobs to make you feel better about your eating disorder." What? My eating disorder? She told me that she thought Keri and I put her on a pedestal because of her body, and she wanted us to feel better. What? How conceited can you be? I felt really violated that she brought up my eating issues. The conversations we

had about eating weren't on camera, and then she brought them up in front of the crew. It wasn't fair.

I see parts of Tonya in me. She thinks to be sexy you have to be blond and tan and have big boobs. She's got that 1980s idea of what's hot. She's definitely not as blond or as tan as she looks. There were times when I thought she looked beautiful, but it's usually when she just rolls out of bed. I was always encouraging her to straighten her hair. I really wanted to give her a makeover.

Theo: Keri was always worried about her appearance. We were downtown, getting some popcorn, no cameras, and I decided to tell her how I thought she was. She probably thinks that Cara and Tonya, being small, are the bombshell. I told her she was the finest woman living in the house. "You have the best body," I told her. I said, "Regardless of what you think of yourself, I think you're off the hook."

Cara: I think it's small-town to be so nervous about your fake t**s.

Peeves

Kyle: I hated how seemingly everyone, except Cara, would claim that as a rule they didn't talk about people behind their backs. They would claim that whatever they said behind people's backs they'd say to their faces. That was such crap. Everybody talked about everybody at some point or another. I say "except Cara" because she and I had the most hilarious s**t-talking sessions, with zero guilt.

Aneesa: Tonya would say the word *boy* a lot. She would say "C'mere, 'boy'." It wasn't particularly racist, she would say that to anybody. But to me and Theo, it was troubling. We had to tell her she couldn't say that. It strikes up images of cotton-picking and all.

Theo: I hated when the camera would be all in my face when I was brushing my teeth or doing my hair. I know that's what *The Real World* was about, but damn, can a brother breathe?

Keri: My biggest pet peeve was Theo hacking in the morning. But when I asked him to stop doing it around me, he did.

Cara: I adore Aneesa, let the record show, but there were things about her that could really bother me. She's not really a polite grown-up, and I don't think she has a clue about it. As an example, my mom gave her a birthday gift and she never said thank you. My sister invited her for the High Holy Days, and she said she would come and then canceled at the last second. She chews with her mouth open. She picks food off your plate. She eats before everyone gets their food.

This is really petty, but when we got to St. Louis, her stuff was everywhere within ten minutes: her shoes were in the kitchen, she was trying on my 14-year-old sister's clothes. She took one of Barrie's shirts home by mistake. I told her to return it, and she was like, "I don't have the address." I was like, "Uh, I can give it to you." Of course, it took her weeks. She just didn't get it. She used my stuff, and I'm a good sharer, but she would make holes in my eye shadows, use my mascara.

I say all this, but I love hanging out with her and talking to her, and I think she's a good friend. She's really quick to be defensive and angry. I have this vision of her reading this and getting all furious. But I know she'll cool down after five minutes. She has a hard time realizing that she's wrong.

Tonya: Partying all night and sleeping all day.

Chris: Drinking out of other roommate's milk cartons and other beverages.

Nudity

Chris: Definitely, Aneesa was the most naked of all the roommates. But Tonya was naked a lot in the hot tub. I think she was doing that just to show off for the filming crews. I love being naked. I didn't get to be naked half as much as I would have liked.

There's nothing I regret except for the seven-person shower. I had been in the hot tub and was showering off with my friend Mark. Aneesa came home and poked her head into the shower. We used to shower together all the time. She'd shower with everyone. Anyway, Aneesa had her friend Veronica with her. All of a sudden, they were in the shower with another random friend. The cameras showed up, and I was feeling so weird. I couldn't come out of the stall because my towel was outside. I cowered in a corner of the shower, sat down, huddled up and thought about my mother and grandmother and sister seeing that. I was so uncomfortable.

Kyle: I was nervous about talking to Aneesa when she was naked. I didn't want to look classless on television. What if my family saw me talking to a girl in the nude and thought it looked bad? I was definitely uncomfortable.

The funniest thing of the season was when production miked Aneesa naked. In order to get miked, you have to be clothed. Well, Aneesa didn't want to be miked. So she just sat around naked. She decided not to get dressed all day. Then, some PA came out with a strip of duct tape and taped the mic over her breast. She walked like that. She could be crass. She would stick her a** in the face of some intern who was miking her because all she'd be wearing was a thong. She knew it would freak them out.

The funniest thing of the season was when production miked Aneesa naked.

Work

Anthony Dominici: I actually liked the cast's jobs. My approach to the show was that they should do community service. I wanted to get away from the corporate job. Why not do a positive thing for a community when you can? I hope it was a good thing.

DINING ROOM SET
THE COUGH

Celebrity Sighting

Keri: We ran into Lance Bass at this bar. We had an idea that the guys from *NSYNC were going to be there. They were having a party for their movie *On the Line*. Anyway, my little sister is a huge *NSYNC fan, being 9 and all. I know all the dances from their videos because of her. I showed up at the bar and met their manager. She brought us into the curtained-off area, and there he was. When I said I was from New Orleans, he flipped out and said it was his favorite city. That's all I talked about the whole season, how much I loved New Orleans, so it was real validation for me.

He's from Clayton, Mississippi, so we have a lot of friends in common. We had a common ground and hung out all night and had fun. He's an awesome guy, not cheesy at all. He knew we were with *The Real World* and was cool about it. He said we should hang out on Mardi Gras. You can tell he's from around New Orleans, where people are more hospitable. It was just nice to talk to someone from home.

He and his girlfriend have known each other since they were kids. They're madly in love, so no, there was no flirting between me and Lance. It was about a hometown vibe for me. I still talk to his girlfriend and manager. We became real friends.

Keri: I thought our lifeguarding job was juvenile. Please! I had a lifeguarding job when I was 15. Everyone we worked with was younger than us. I was answering to people who were 12. It was embarrassing. But at the same time, it ended up being a good release. It ended up being time off from the cameras, because they didn't really follow us there.

If we had gone on a real vacation, to Eastern Europe where we were supposed to go, our second job would have been cool. Our bosses were cool and we were working together, but the job was pretty lame and tedious, if you ask me.

Last season, the cast worked for Arista and got cool laptops. We were doing plays for 5-year-olds. *Real World* 11: The Shaft. We got jobs that real people could get, we didn't get jobs that had anything to do with privilege. The cast before us got the mad hookup. We were like, "Hello, Are you kidding?"

Aneesa: They could have picked a better job for us, but what can I do? Tonya was awful with the kids. She was never there, and when she was, she played favorites. Theo, Cara, and I made a point to kiss and hug all those kids equally. It's a shame Tonya couldn't step up. She could have really helped those kids. I'm sure she would have had something positive to offer, but she didn't do it.

Kyle: Chris's self-centeredness and ambition came out in our jobs. He asked a director if his doing the plays for our job would have a negative effect on his acting career. I think Cara also thought about that, but she didn't spend time worrying about it. I'm just worried that all that is going to go to his head.

Theo: I told Chris the one thing I didn't like about him was when he bitched too much about work. We were at work and I told him he acted like a little punk. You're a grown man and you should not complain about our job.

Please! I had a lifeguarding job when I was 15.

Anthony Dominici: The house is built for interaction. You can't go into a corner and isolate yourself. That said, there's privacy. We don't film in the bathroom stalls—though I don't know if certain cast members, namely Aneesa, would have cared if we did.

the

Jonathan Murray, creator:
We had these minor demonstrations at the beginning of the season. The demonstrators were people who felt that having *The Real World* in their neighborhood would further gentrification—even though we were long preceded in the neighborhood by a Starbucks. It was difficult for the cast logistically, but I think that whenever you have some controversy about the show, there is some anticipation to see just what the fuss is about. In the end, it helped us.

house

Anthony Dominici: We began our house search by looking for a cutting-edge neighborhood. We settled on the Bucktown/ Wicker Park area.

"The house is built for **interaction.**"

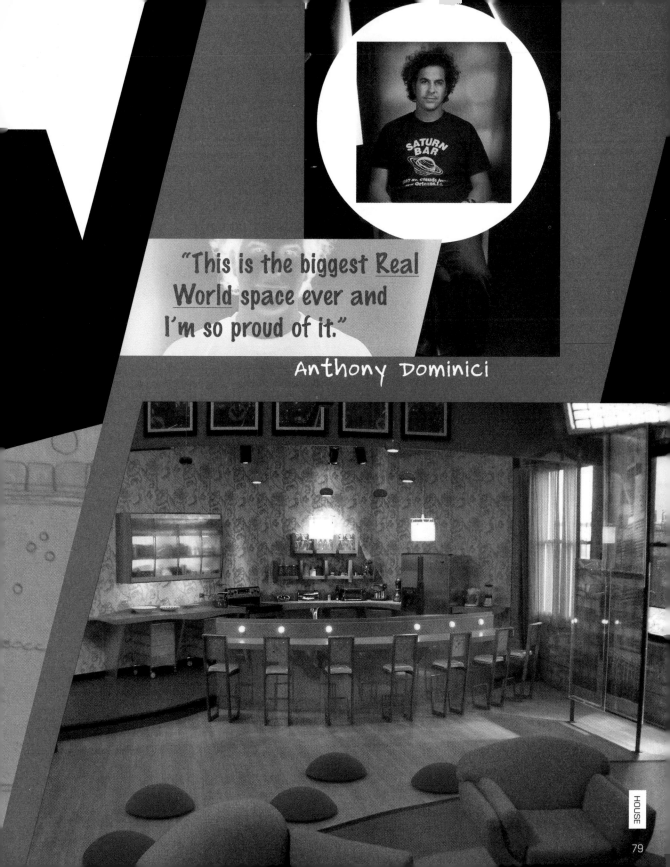

"This is the biggest <u>Real World</u> space ever and I'm so proud of it."

Anthony Dominici

"My approach to the whole house was to take it further...

I wanted to make it ergonomic and fluid. For me, the house is art. All of the artwork in the space is either commissioned or curated by the Chicago Museum of Contemporary Art. Everything that's part of the house is an installation; it's an artistic experience."

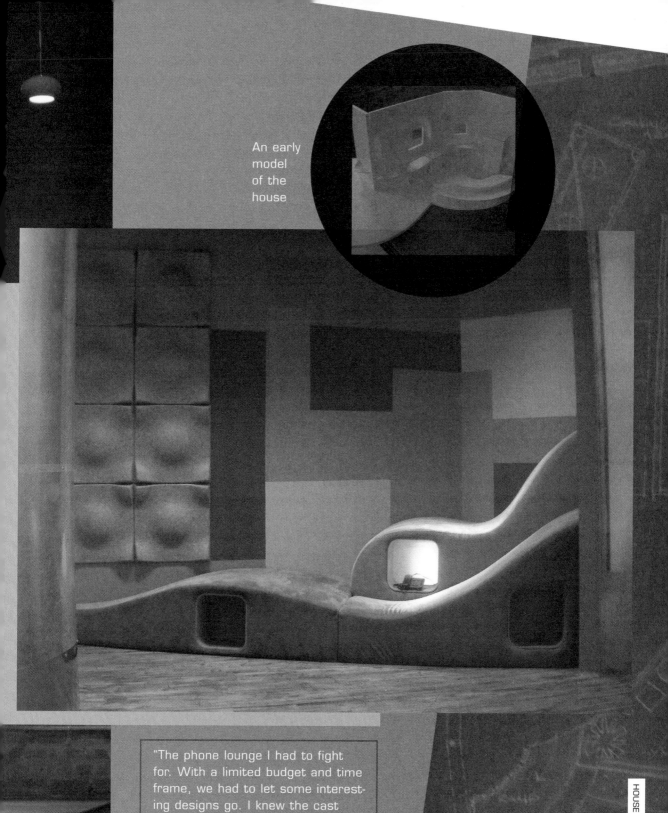

An early
model
of the
house

"The phone lounge I had to fight
for. With a limited budget and time
frame, we had to let some interest-
ing designs go. I knew the cast
was going to hang out here a lot,
and I wanted it to be different."

"we wanted to use the house to encourage movement."

"It used to be a coffee shop, then an antique shop. When we got the space, it was wood floors and brick walls. Initially it was a square space, completely empty. We wanted to use the house to encourage movement."

Chris: Aneesa and I had the most intense, tearful talk in the bird's nest. That was definitely one of my favorite spaces in the house.

Keri: My favorite room was the kitchen. I spent a lot of time cooking. I was basically the only one who could.

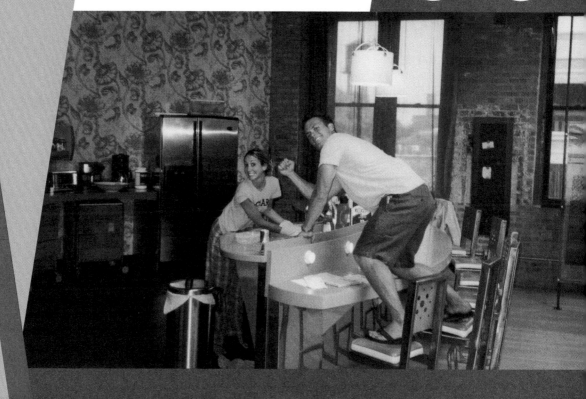

"What I call the bird's nest—the cast calls it the genie bottle—is my favorite space. I wanted to make a small private space: a guest bedroom, reading room, a room that's semiprivate and not completely open."

confessional

"...a camera-friendly environment."

"We had nine weeks from me moving to Chicago and signing the lease to move-in. Once the cast moves in, it's a hot set and the crew isn't allowed to touch anything— no painting, no redecorating. People were essentially working 24/7. As someone who'd actually been a director on the show, I didn't want to create a space that was difficult to film in. I was very conscious of creating a camera-friendly environment."

"The most expensive piece was the Capellini bookshelf."

"We blew out windows from the house and made an outdoor patio area with a spa."

"We also wanted the house to be an experience. I talked to the production designer a lot about mood and color arcs, so that when you walked in through the space you'd get the feeling that the house was inviting you in. The lobby is intentionally simple and typical with grays and muted tones. But as you walk toward the elevator, the colors get hotter. You take the red elevator to the top and then the whole space explodes. It's one huge 4,000-square-foot room with no walls. You see everything from one vantage point."

"You see everything from one vantage point."

Kyle: The only place where you weren't being filmed was the toilet, so people used to go in there and cry. Aneesa would be on the phone, crying, the cameras would be following her, then she'd run to the bathroom stall and sob.

"The elevator gave us an opportunity to do something really cool. We wanted to make it fun and interesting to get to the third floor. We put the fish tank on the way up. You look into the bathroom through the fish tank. You can also see who's coming into the house through the fish tank."

"The crew area was on the first floor behind the lobby wall."

"The double showers turned out to be really expensive. We had all these tiles flown in from Italy. Everything was either custom-made or imported."

"When we put in the double shower, we never would have imagined that we would get the kind of fun that it produced. We were hoping we'd get it, but we were really blessed."

Jonathan Murray, creator

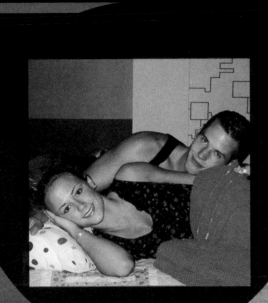

"We did three bedrooms—that's typically how the *Real World* house works. You don't want to give seven people seven rooms, they'll never see each other."

"You don't want to give seven people seven rooms..."

Jon Murray, creator: For Chicago, our eleventh season, we redoubled our efforts to cast people who couldn't help but be themselves. We wanted cast members who were strong enough and sure enough of themselves that they weren't afraid to say and do what they felt. For the most part, we succeeded. As a group, this was probably the least guarded cast we've had on *The Real World*. Partly because of this, I think the cast got along better than past casts. Like a family, they weren't afraid to fight with one another. And, like a family, they quickly forgave each other and moved on. I think that's why they will leave Chicago with mostly good memories and good feelings for one another.

cast

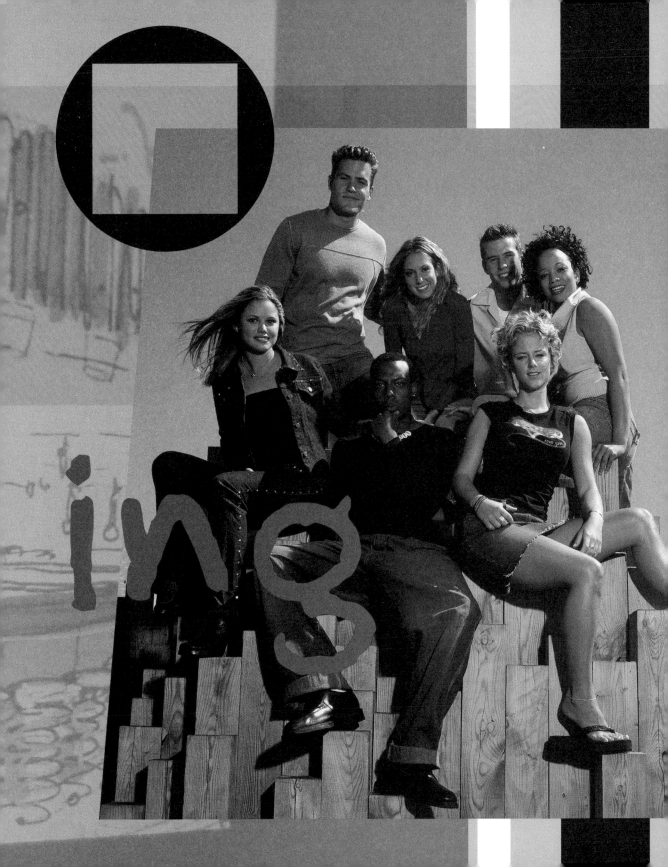

I had a gut sense this was going to come through for me. I knew I had a good chance, being both alcoholic and gay.

Chris

Casting Q & A

How did you first apply? Two friends from the gym, Stacy and Laura, told me about an open call. I went to it and just let loose. Honestly, I thought I had it right from the beginning. It was like I had a gut sense that this was going to come through for me. I knew I had a good chance, being both gay and alcoholic. Plus I'm an honest person. I left myself wide open.

Were you a *Real World* watcher? Before I started the casting process, I'd probably seen a couple of episodes from San Francisco. I loved Pedro and got a lot out of seeing him on television. I watched some of the New Orleans season. I thought Danny was adorable. And I definitely watched the Casting Special for New York, looking for pointers.

Which is your favorite cast and why? If I had to pick, it would be San Francisco. I've talked to people who came out because of Pedro, and that is so powerful. I wanted to do that for people.

Describe the home video you submitted: I did a walk-through of my house and my neighborhood and my art studio, and made a lot of fun of my roommates.

What did you think when you flew to L.A.? I wasn't thinking too much. I was trying not to concentrate on what was happening and not get too nervous. I just wanted to show up and be me, and see it from there.

What did you wear? Comfortable Abercrombie clothes.

Any highlights from your interview? It was hellish. Anyone and everyone came in to grill me. It was a firing range of questions. They wanted to see how strong I was emotionally, if I would break down. This one guy, Bruce, came in and he really pissed me off. He tried to get me to go deeper and deeper. We got into a heated discussion. I started to get really aggravated. As soon as we were done, he was like, "Good job. I just wanted to get a rise out of you."

Where were you when you found out you got on *The Real World?* I was in my car driving around. I pulled over when the cell phone rang. I'd known I was going to Chicago, but then it was official.

Who was the first person you told? My 14-year-old sister was in the car with me. She was freaking out. She's a huge fan of the show and thought it was the best thing ever. She called her friends before I called mine.

Did you ever think, *What have I gotten myself into?* I didn't think that until I got to Chicago.

What did your family/friends/boyfriend/girlfriend think? At that point, I didn't have a boyfriend. I was only dating somebody. I just got great support from everyone. Nobody was nervous about what I'd say or anything. It was all just nice.

How did you prep to be on *The Real World?* I put everything in storage, found a subletter for my apartment, settled some bills, gave notice at work, canceled some gallery shows, and took off to Chicago. That was it. I also did a bunch of retail therapy.

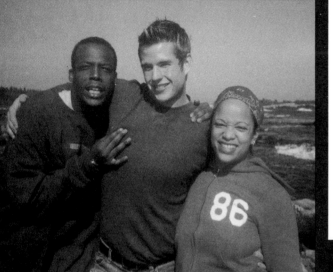

CHRIS'S APPLICATION

First and middle name: Christopher

Age: 23

Presently living in: Boston

Parents: Deborah and Stephen

Siblings (names and ages): Erin 14, Randi 21

What is your ethnic background? Irish and German

Name of high school: Coyle-E-Cassidy

Name of college (years completed and majors): Suffolk University and University of Massachusetts, 3 years completed

Other education: Trained in outreach for HIV prevention

Where do you work? Describe your job history: Currently a customer service representative at a dot-com company. Also have a part-time job at a shoe store.

I'm an honest person.

CASTING PREFERENCES

Read books: In my spare time

Sleep 8 hours: I try to

Watch television daily: Never (no time)

Shop: When necessary

Go out/party: Once a month

Spend time with friends: A lot of time

Spend time alone: Sometimes

Balance work/study: Balance is a very hard thing

Talk on the phone: I love talking on the phone

Cook: When necessary

Clean: Kind of neat

Write e-mail: Every day

Read newspapers: *New York Times* arts section, *The Wall Street Journal*

Play with animals: When I am around them

State opinions: Always

Ask opinions: Always

What is your ultimate career goal? I would love the opportunity to own my own gallery. My dream is to be alive to see my artwork hung at the Museum of Modern Art, Museum of Fine Arts, or the Whitney Museum.

What artistic talents do you have (music, art, dance, performance, film/video making, writing, etc.)? How skilled are you? Drawing, painting, sculpture, photography, and print work. I am currently working on my first commissioned work of art.

What about you will make an interesting roommate? Diverse, multicultural experience.

How would someone who really knows you describe your best traits? They would probably describe my best traits as outgoing, honest, true to myself. My ability to set a plan and follow through with it.

How would someone who really knows you describe your worst traits? That I am highly opinionated. I have been called "melodramatic."

Do you have a boyfriend or girlfriend? How long have you been together? Where do you see the relationship going? I don't have a boyfriend AT THE MOMENT!

What qualities do you seek in a mate? I seek attraction on all levels. A good intellect, mature goal/day dreamer mind-set. The same morals and values I have.

How important is sex to you? Do you have it only when you're in a relationship or do you seek it out at other times? Sex for me has changed over the years. It can be very healthy. I enjoy it much more when I am in a committed relationship. The last time it happened I was with a guy I had dated for a couple weeks.

I left myself wide open.

Confide in your parents: I am so honest with them both

Volunteer: When I have time

Procrastinate: 20% of the time

Eat: A lot! Six small meals a day

Get drunk: Not since February

Diet: Constant battle

Vote: Every time

Cry: When I feel emotional

Laugh: I love to laugh

Instigate: Only if provoked

Cinema: Love movies

Theater: Love musicals

Concerts: I like to go to them

Clubs: Sick of them, but I still go out

Parties: Depends on the party

Surf the Web: When working

Chris: I saw the Hawaii season with Ruthie. I saw the episode where they told her she either had to leave or get help. I've been there. I've been sat down so many times by family and friends. No one can tell you you're ready if you're not. If I get on the show, I know I'm going to be in a difficult position.

Describe your fantasy date: Depends on the mood I am in. It would probably be with someone I could see myself with for a long time.

What do you do for fun? I love to go to art exhibits locally and in New York. I paint in my studio whenever I have a free moment. I go to the movies and on long drives to the Cape. I have a very healthy, active lifestyle.

What are your favorite musical groups/artists? Portishead, Tricky, Stan Getz, Radiohead, and lots of other different sounds. From Mozart to Depeche Mode.

Describe a typical Friday or Saturday night: I usually go out to dinner on Friday nights and to the movies. I might go out dancing. Saturday nights and Sunday are for painting and hanging around town with friends.

Other than your boyfriend or girlfriend, who is the most important person in your life right now? My best friend, Sandra. She is like my sister. I have known her for eight years. She's been through it all with me. A true golden friend.

What are some ways you have treated someone who has been important to you that you are proud of? Recognized their strengths, loved and accepted them for who they are. Hold open arms whenever they need a shoulder to cry on.

What are some ways you have treated someone who has been important to you that you are embarrassed by, or wish you hadn't done? None.

Describe your mother: My mother has always been supportive. Her support, of course, has shaped me as an individual. Supporting me emotionally. She's my best friend (she is so strong!).

Describe your father: My father hasn't been there for me throughout most of my life. He means well but a disease took him to another place. We now have a mature, adult relationship. We have reconciled all differences.

If you have any brothers or sisters, are you close? How would you describe your relationship with them? Me and my adopted sister are the closest. I basically raised her when she was adopted. My other sister is from my father's second marriage.

What is the most important issue or problem facing you today? My sobriety. I made a promise to myself almost a year ago. I have been free of alcohol for three months and I am very proud of it.

Do you believe in God? Are you religious or spiritual? Yes, I believe in God. I am both religious and spiritual.

What are your thoughts on people who have a different sexual orientation from you? I accept all walks of life. If I didn't, where would I fit in this society, being gay?

Do you have habits we should know about? Aside from working out a lot, no.

What bothers you most about other people? I really get bothered by fake people. People who are scared about "what other people will think."

How do you handle conflicts? Do you feel that this approach is effective? I am very confrontational. Not in a bad way. I like to really talk about a problem before it develops into something much bigger.

If you could change one thing about how you look, what would that be? It would have to be "my looks." I am often judged by them alone.

If you could change one thing about your personality, what would that be? Being set in my ways, being very opinionated on certain issues and standpoints.

If you had Aladdin's lamp and three wishes, what would they be? The first is that my great-grandmother would live forever. The second is that there would be a cure for Hepatitis C and HIV and other diseases that claim lives. Third, for us to have a society in the United States that doesn't discriminate by race or sexual orientation.

I am both religious and spiritual.

NEW YORK 35

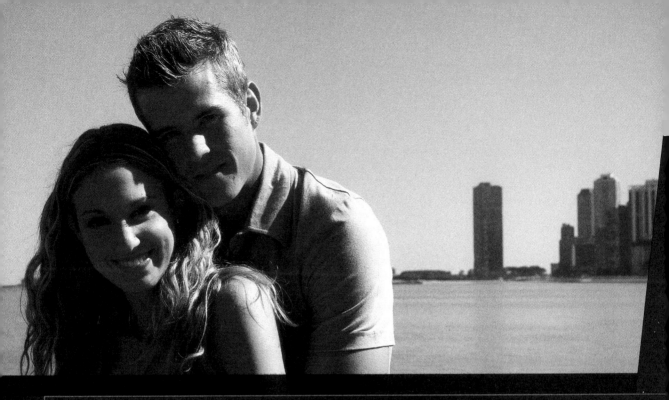

CHRIS'S FAVORITES

Cocktail: It is a definite toss-up between a side-car or Ketel One dirty

martini, extra olives

Breakfast: Challah French toast with seasoned roasted potatoes

Fast-food item: McDonald's fries

Cuisine: French

Scent: Fresh Linen Scent (Lysol)

Car: The new Lexus SC 400 or a '54 T-Bird or the Porsche SUV

Brand of clothing: Diesel or Zenga

Item of clothing: Any vintage T-shirt

Accessory: Cell phone

Sneakers: New Balance

Magazine: *Out* and *ArtNews*

Book: *The Prophet*, Kahlil Gibran

Movie: This is tough...I love anything by John Waters

Television show: I hardly ever watch TV

Hour of the day: Sunrise and moonrise

Song to do karaoke to: It would have to be Janet Jackson's "Nasty"

Actor: Robin Williams

Actress: Ally Sheedy or Jodie Foster

Cartoon character: Smack Attack Chicken and Gerbil

Sports team: Boston Red Sox

First date: It wasn't memorable

Outfit to sleep in: Flannel shirt and cotton pants

Video game: I hardly ever play them

In The House

Who was the...

Best dressed: Cara

Worst dressed: Kyle

Best dancer: This isn't easy...Aneesa

Worst dancer: Kyle

Why Chris Was Cast

Anthony Dominici: Chris was cast because he's a really interesting person. You meet him and you want to know more—he's intriguing. Chris really zipped through the casting process. We found him late and fell in love with him instantly. He had these gorgeous blue eyes. He's an artist and had all these qualities we hadn't seen before.

Kenny Hull: For one reason or another, we didn't get very strong applicants from the gay community. Late in the process, we did a huge search in the Boston area. Chris walked into the room with a halo around his head. He is so good-looking and smart and such an obvious choice. He's complex and determined to become a better person, and isn't sure who he really is quite yet. He has solid Boston values—he wants to take care of his sister and his mother. As a kid, he had to fight his way home from school. We were very openly concerned about his alcoholism. We asked him to think about whether the show would compromise his sobriety. He handled it well. He thought hard, but then did what he set out to accomplish. His is a good story, and it's something young people will relate to. You *can* kick stuff.

Best cook: Keri

Worst cook: Tonya

Most hygienic: Me

Least hygienic: This is a tough call...Kyle

Most diligent: Theo

Biggest procrastinator: Aneesa

Best mannered: Keri

Worst mannered: Aneesa

Best attitude: Cara...she never disagrees

Worst attitude: Keri, when she wants to get her way

Best in the morning: Tonya

Worst in the morning: Me

Most naked: Aneesa

Most Overused...

Item of clothing: Tonya's purple shirt or Tonya's green bathing suit or our lifeguard shorts or Kyle's boxers

Expression: Neven

Excuse for not cleaning: Money and other important things like sleep

Line used by someone to get into the Real World house: "Oh my God. Can I please come in? Please?"

I'm often judged by my looks alone.

I had to tell my dad: "Look, dawg, don't go telling the folk. MTV wants me to keep it on the low." That next Sunday, he told the entire church.

Theo

Casting Q & A

How did you first apply? When I was 14, I announced that one day I was going to be on *The Real World*. Then, last year, I was at a basketball game and there was an announcement about an open call. You know I was going to go. The first thing they did was put us in a circle. I probably talked 70 or 80% of the time. I got pulled aside and asked to fill out an application.

Were you a *Real World* watcher? I am a huge fan of *The Real World*. I really started watching with Seattle. I thought they looked like they were having the time of their lives. I definitely imagined myself in that scenario.

Which is your favorite cast and why? Hawaii was off the hook. Ruthie was adorable even in her drunken state. She had her problems with her own personal life, but she did the best to make it better. Kaia was a beautiful woman with a dynamic body. She had that mystery. I got a lot out of the Colin and Amaya relationship. I learned how women can really fall for guys in a bad way. Colin wanted a** and she fell in love. I've had some fall for me. Teck was my all-time favorite. He was all about having a good time. I didn't think I'd make the show 'cause we had too much in common. We're both preachers' sons.

Describe the home video you submitted: It wasn't too exciting, just a day in the life of me and my friends. I showed them my car and my classroom, the yard, the cafeteria where we all kick it and hang out. Just that.

What did you think when you flew to L.A.? I was in shock mode. I was thinking to myself, *Don't act. Don't try to be funnier than you are. Just be yourself.*

What did you wear? I wore a red turtleneck, a pair of black jeans and these red, black, and gray Nikes. You gotta match.

Any highlights from your interview? They asked me what type of woman I liked and could I draw that type of woman. I drew a picture of a woman's a** and thighs. I don't want my women too thin. I don't want there to be a gap between their thighs. I drew some thick legs and a booty cheek.

Where were you when you found out you got on *The Real World?* My mom and I both work at this outreach center. We were on a break chatting and the cell phone rang. My mom started running around the office screaming, "My baby done made it!"

Who was the first person you told? My mom, and then my dad. I had to tell my dad, "Look, dawg, don't go telling the folk. MTV wants me to keep it on the low." The next Sunday, he told the entire church.

Did you ever think, *What have I gotten myself into?* Honestly, no, this was what I'd wanted. I'd been preparing myself. I wanted to represent myself and have a good time.

What did your family/friends/boyfriend/girlfriend think? They were all like, "You deserve it." My girlfriend and I had already broken up. I thought she might wanna be all on my team, thinking I was gonna blow up, so she'd want to hang on to me. But she was just nice, like "Oh, baby, it's good."

How did you prep to be on *The Real World?* I spent time with my family and friends. I got a couple of new clothes, of course. I got a haircut the day I found out.

THEO'S APPLICATION

First and middle name: Theodus E. III

Age: 19

Presently living in: Alabama

Parents: Vickie and Theodus II

Siblings (names and ages): none

What is your ethnic background? Black

Name of high school: John W. North

Name of college (years completed and majors):
Tuskegee University, 1½ years completed

Other Education: —

Where do you work? Describe your job history:
No current job. Worked as a delivery
boy. Last summer I had an internship in
an architectural firm.

What is your ultimate career goal? To be a
licensed architect and own my own firm
by the age of 35.

**What kind of pressure do you feel about your
future?** I feel that I have no choice but to
be successful. My dad put some pres-

I have no choice but

CASTING PREFERENCES

Read books: Sometimes

Sleep 8 hours: Not all the time

Watch television daily: Yes, *The Real World*,
Martin, *Blind Date*

Shop: Yes

Go out/party: Hell yeah, every weekend

Spend time with friends: A lot of time

Spend time alone: Sometimes, usually in
the morning

Balance work/study: All study, no job

Talk on the phone: Not too much, I like talking
face-to-face

Cook: Yep, George Foreman Grill

Clean: Yep, it can get dirty

Write e-mail: Yes, often

Read newspapers: Not really

Play with animals: Sure

State opinions: Of course

CASTING

sure on me, but not too much. But because I am the pastor's son, I have a lot of pressure. I am supposed to be better than others and not get into trouble, but I'm just human.

What artistic talents do you have? (music, art, dance, performance, film/ video making, writing, etc.)? How skilled are you? I can sing pretty well. I can also draw.

What about you will make an interesting roommate? I am focused and I know what I want in life. I can also be a good listener and give good advice. Some people can't take it when I tell the truth. But like people say, the truth hurts, so be it.

How would someone who really knows you describe your best traits? I am talented and smart. I enjoy helping others when the opportunity presents itself. I am honest and trustworthy. And last, I like to make people laugh. If someone is feeling down, I try to pick them up.

How would someone who really knows you describe your worst traits? My worst trait is that I can get a temper real quick. Especially when females say something

smart. Some people think I am conceited, but I'm not. And also that I use foul language a bit too much.

Do you have a boyfriend or girlfriend? How long have you been together? Where do you see the relationship going? I had a girl, but we broke up on our four-month anniversary. It was a long-distance relationship and those things just don't work. Even though it's over I still love her and in the end I want to marry her. But if that doesn't happen then it wasn't meant to be and I ain't trippin, 'cause there are a lot of fish in the sea and trust me, I don't have a problem getting any of them.

What qualities do you seek in a mate? Beautiful, honest, caring, and one who doesn't mind the man being the leader. Not to say she has to follow me. But let me run things, let me take care of them.

How important is sex to you? Do you have it only when you're in a relationship or do you seek it out at other times? Sex is real important. I have had sex with someone when we weren't together but the sex is best when you are in love with that other person.

to be successful.

Ask opinions: Yes	**Laugh:** Oh yeah
Confide in your parents: Yes	**Instigate:** Nope
Volunteer: Yes, feed the homeless	**Cinema:** Love the movies
Procrastinate: A little	**Theater:** Love plays
Eat: Love to eat lobster and steak	**Concerts:** Yes
Get drunk: Yes I do, but not all the time	**Clubs:** But of course
Diet: Hell no! I'm in good shape	**Parties:** But of course
Vote: Next election I will	**Surf the Web:** Not too much
Cry: Yes	

Theo: It won't bother me if I'm the only minority in the house. That guy—what was his name?—the one who slapped a girl, he made an outcast of himself. I'm going to go in there and be the one who's introducing myself to everyone else, saying it's time to go and kick it. We gonna be tight. I'm not gonna be the loner guy. I know I can interact with people well, doesn't matter who black, white, Mexican. Now, if we're talking women, I do have a preference: if you gave me a fine black woman and a fine white woman, I'm going to pick the black woman. Simple as that.

Describe your fantasy date: My fantasy date is with Jada Pinkett Smith. She comes to my dorm room to pick me up but we never leave the dorm and then I get out the candles and chocolate-covered strawberries and go to work.

What do you do for fun? I go out to clubs. I love to dance and get "crunk." I also rap sometimes with my boys, just playing around. But more than anything, I like to approach young ladies and see if I can get their number or anything else from them. That's real fun.

What are your favorite musical groups/artists? Dru Hill, Outkast, Snoop Dogg (Westside), Eminem, Mystikal, 112, Lucy Pearl, Limp Bizkit, Korn, Hot Boys, B.G., *NSYNC (They alright, they can dance for some white guys.)

Describe a typical Friday or Saturday night: Get in the shower, get dressed. See what's crackin' by calling people. If nothing is going on, get on a solo mission, which is try to get with one of the females I am talking to and try to get something crankin'.

Other than your boyfriend or girlfriend, who is the most important person in your life right now? My dad. Even though we have had our disagreements, we are still cool. He is a pastor of a church, but when we are at home, he is my dad. He's a cool guy. When my friends meet him they never expect that he's a pastor, because he is so down-to-earth.

I know I can interact

What are some ways you have treated someone who has been important to you that you are proud of? I let them know I am proud of them face-to-face or even in front of others. I keep encouraging them to do better and never give up. And let them know that I have their back and they can count on me.

What are some ways you have treated someone who has been important to you that you are embarrassed by, or wish you hadn't done? I've never had an incident like that happen to me.

Describe your mother: She is loving, supportive, and encouraging. Hardworking and smart. She lets me know she loves me and even though I am grown she tells me she can still knock me out.

Describe your father: He's a preacher/pastor—man of God, the one you run to when you have a problem. Responsible and outgoing.

If you have any brothers or sisters, are you close? How would you describe your relationship with them? I don't have blood brothers but God brothers, and we are real close. We have known each other for like fourteen years.

What is the most important issue or problem facing you today? Being successful. Not failing out of college. I want to be rich and famous. It doesn't have to be TV-type fame, but I want to be remembered as one of the greatest architects, like Frank Lloyd Wright.

Do you believe in God? Are you religious or spiritual? But of course. I am Christian and my denomination is Baptist.

What are your thoughts on people who have a different sexual orientation from you? I think being gay is terrible. God made Adam and Eve, not Adam and Steve.

Do you have habits we should know about? I smoke cigarettes sometimes. I also like to drink.

What bothers you most about other people? When they act like they are the s**t. I hate that. Also, when people lie. There is no need to lie. Oh, and when they lie about girls they have been with and come to find out they didn't do anything with them. They are weenies.

How do you handle conflicts? Do you feel that this approach is effective? I try to talk my way out of it or ignore it and that tends to be effective.

If you could change one thing about how you look, what would that be? I would add on an extra twenty pounds, 'cause I can't gain weight.

If you could change one thing about your personality, what would that be? Not to get angry about silly, petty things. Learn to calm myself down a little better.

If you had Aladdin's lamp and three wishes, what would they be? 1) I would wish for whatever my mom wanted. 2) Wish for what my dad wanted. 3) Wish to own a successful architecture firm by the age of 35.

with people well . . .

> I like to make people laugh. If someone is feeling down, I try to pick them up.

THEO'S FAVORITES

Cocktail: Hennessey and Coke

Breakfast: Eggs, bacon, pancakes

Fast-food item: Whatever

Cuisine: Whatever

Scent: Very Sexy cologne from Victoria's Secret

Car: Anything that draws attention

Brand of clothing: Don't matter as long as it looks good on me

Item of clothing: Jeans

Accessory: My shell necklaces

Sneakers: ES skater shoes, Air Force One

Magazine: *Vibe* and whatever magazine this is going into

Book: *The Maintenance Man*

Movie: *Scarface*

Television show: *The Sopranos*

Hour of the day: After 10 pm 'cause the freaks come out at night

Song to do karaoke to: Don't matter

Actor: Denzel Washington/Will Smith

Actress: Don't have one

Cartoon character: Thundercats

Sports team: Dallas Cowboys/Oakland Raiders

First date: I can't even remember that one

Outfit to sleep in: Shorts/boxers

Video game: Grand Theft Auto

In The House

Who was the...

Best dressed: I don't know. I didn't really care

Worst dressed: Same as above

Best dancer: That was me and Nanu

Worst dancer: Chris

Best cook: Keri cooked the most and it was always good

Worst cook: Nobody really, not too much cooking took place in the house

Why Theo Was Cast

Anthony Dominici: Theo presented himself to us as a determined, intelligent guy with an interesting family past. He's at the age and time of his life when he wants to separate from his family. He's a really funny guy who was cracking us up in casting.

Kenny Hull: Theo was just so with it in casting. He had MTV written all over him. We found him in New Orleans. During the casting call, he spoke up regarding relationship issues. He's an honest guy. You can look him in the eye and know he's telling the truth. That's such a blessing in a cast member. It's really easy to tell someone's story when there's no guesswork, when the person is real—not to be cliché. In casting, he had so much fun. He did karaoke, danced around like a *Solid Gold* dancer. He wasn't nervous at all, which is amazing, because casting is not the most normal situation.

Most hygienic: Tonya, she would go brush her teeth between meals—ain't nothing wrong with that, though

Least hygienic: The house was always dirty

Most diligent: All of us were pretty diligent

Biggest procrastinator: Nanu

Best mannered: I let you tell it

Worst mannered: Same

Best attitude: I let you tell it

Worst attitude: Same

Best in the morning: It varied

Worst in the morning: Me, at times, especially if someone said something smart or was talking s**t about me when I got up in the morning

Most naked: Aneesa

Expression: Neven

Excuse for not cleaning: "I forgot" or "I clean all the time"

Line used by someone to get into the Real World house: "Can you give me a tour?"

Most Overused...

Item of clothing: The black sweater that all the girls wore

Everyone at my school was like, "You're so *Real World*." Is that a good thing or a bad thing?

Cara

Casting Q & A

How did you first apply? I had a friend in the theater department who told me there was open casting for *The Real World*. Everyone at my school was like, "You're so *Real World*." All I could think was, *Is that a good thing or a bad thing?* I went to the open call and I didn't get called back, but then I got an e-mail from the casting department asking me to try out. My gut feeling was that I'd make it really far in the casting process, but not that far. I didn't think I was controversial enough.

Were you a *Real World* watcher? Minimally. I wasn't for or against it. I just wasn't so up on the reality-TV thing.

Which is your favorite cast and why? I don't know it well enough to have a favorite cast. Once I was cast, I watched the ten-year reunion. I thought it looked fun. I watched some of the Miami season with my mom. It scared me, yeah, definitely.

Describe the home video you submitted: It was supposed to be a five-minute tape and I sent in a twenty-minute tape. It was pretty natural, nothing too out of the ordinary. Jared filmed me singing with my a capella group. Jared's in it himself.

What did you think when you flew to L.A.? I ended up getting bumped up to first class, so I was pretty psyched. On the flight, I said to myself, *Cara, just get this.* To be honest, I kind of get what I want in life. Men, material things, opportunities, I'm pretty blessed like that. I thought this was a real challenge, a big audition, and I should land it. I could have dealt with it if I didn't. I have had rejection in the theater world. Failure is hard. It takes a toll on the ego, you know.

Where were you when you found out you got on *The Real World*? I was irritated with the whole casting process. I'd put my life on hold, I couldn't apply for jobs. I had planned to go to Martha's Vineyard with my family and I didn't know if it would be for the entire summer or just a week. On June 29, the day they told us we'd find out, I woke up and started drinking beer. I never drink first thing in the morning, but I was just too nervous. My cell phone rang, and I answered it by saying, "Just f**king tell me." The person on the other end said, "You're not gonna wanna use that language now that you're on *The Real World!*"

Who was the first person you told? My ex-boyfriend was in the room at the time. Then I called my three best friends, Jared, all my siblings, and my parents. Obviously, everyone told everyone else. In one day, everybody at Wash U knew.

Did you ever think, *What have I gotten myself into?* Yes. I kept thinking, *I can't believe this is happening.* I'd gotten so swept up in the auditions and landing it. I'm not sure I'd considered how this could change my life when I signed the contract. It seemed like such a sweet opportunity.

What did your family/friends/boyfriend/girlfriend think? My family was really excited. My brother applauded me by saying there are better odds of getting into Harvard Med. They thought, *It's about time the country got to know you!* Jared gave me a very solemn congratulations. He was bitter. I had the occasional peripheral friend be like, "Are you sure you're ready for this?" I didn't want to hear it.

How did you prep to be on *The Real World*? I had a good week in the Vineyard lying out. I got a bikini wax and my hair highlighted and bought myself a new suede jacket. I bought a Boston Red Sox shirt and a St. Louis Cardinals shirt and Wash U clothes and sorority shirts. I wanted to be garbed to represent.

CARA'S APPLICATION

First and middle name: Cara

Age: 21

Presently living in: University City, Missouri

Parents: Rhoda and Sam

Siblings (names and ages): Jeffery 25, Barrie (girl) 14

What is your ethnic background? American

Name of high school: The Rivers School

Name of college (years completed and majors): Washington University in St. Louis. 3 years completed. Theater major.

Other education: Life.

Where do you work? Describe your job history: I presently am a Virginia Slims girl. I give out free packs of cigarettes at clubs...sort of like a modern Betty Boop or something. I worked at a tanning salon for a while. I usually stick to retail in the summer.

What is your ultimate career goal? Ideally? I want to be on a sitcom. I'm funny. I really am. And I can be really cute. Yes I can. Realistically? I'll probably go back

CASTING PREFERENCES

Read books: It makes you smarter. I do it when I can (i.e. vacations).

Sleep 8 hours: At least 8

Watch television daily: *Sex and the City, The Simpsons, Facts of Life*

Shop: I believe in retail therapy

Go out/party: Yes, but just as happy staying in with my roommates

Spend time with friends: I hate being alone most of the time

Spend time alone: Not so much

Balance work/study: I'm horrible at it. Can't plan in advance for s**t

Talk on the phone: Not as much as you would think. I like to talk in person

Cook: When I have time

Clean: When I need to

Write e-mail: I enjoy writing in a journal. E-mail when I have time

Read newspapers: I want to make it a priority

Play with animals: I love my cats. I love dogs, too

to school eventually and get a master's in education. I want to teach middle school—maybe even drama.

What kind of pressure do you feel about your future? I don't feel much pressure. My parents legitimately want me to be happy.

What artistic talents do you have (music, art, dance, performance, film/video making, writing, etc.)? How skilled are you? I sing. I act. I make people laugh. I'm pretty good, especially at singing.

What about you will make an interesting roommate? I make people laugh. I mediate. I keep people in good spirits. I'm encouraging and supportive. I'm inquisitive. I'm fun, open, I'm a flirt. I can be very weird. I'm daring. When I get hungry, I get bitchy. It's interesting and entertaining.

How would someone who really knows you describe your best traits? Witty, "genuinely interested in people," says one of my roommates. I go out of my way to make everyone comfortable. I'm quirky, warm, realistic, "encouraging and enthusiastic," says another roommate.

How would someone who really knows you describe your worst traits? I'm not picky enough. Too trusting. Think everyone's "nice."

Do you have a boyfriend or girlfriend? How long have you been together? Where do you see the relationship going? Yes, I have a boyfriend, Jared. We've been together nine months. It's "serious." I've been known to say this before, but I really feel that I could happily spend the rest of my life with Jared.

What qualities do you seek in a mate? Friendly, supportive. Liked by many. Positive. I like them to be attractive, with a penis and a pulse, preferably.

How important is sex to you? Do you have it only when you're in a relationship or do you seek it out at other times? I really like sex. It's important to me, but honestly, I'm not too selective. I have sex with people that I'm not in relationships with. But usually I'm in a relationship with the person. In retrospect, I haven't been selective enough.

Describe your fantasy date: Really nice dinner with mucho vino and a drive-in movie (kind of simple).

What do you do for fun? Drink, walk, shop, give myself manicures, mingle, people-watch, make chicken salad, watch movies, quote movies, look at photos,

State opinions: I do

Ask opinions: Yup

Confide in your parents: A little

Volunteer: I hate to say this, but I'm too selfish with my time

Procrastinate: Really well when it's s**t I don't want to do

Eat: One of my favorite activities

Get drunk: When I'm in the mood

Diet: Sometimes

Vote: Why wouldn't I?

Cry: When I can, sometimes my tears are muted

Laugh: When I can, as much as possible

Instigate: A little

Cinema: Love the movies

Theater: Yup, love it for special occasions

Concerts: Used to love them, now only people I really want to see

Clubs: I'm not so into clubs (loud, cheesy, etc.)

Parties: I like to party

Surf the Web: No thanks

Cara: My older brother is everything my dad ever wanted in a son. From playing football to working for the President, he's everything he always wanted. My sister is also really athletic. I don't think he would have been proud of me if I didn't go to a good school. That said, I don't think he's incredibly supportive of my being a theater major. I flirted with the idea of law school, and I think he would have liked that. I'm just always trying to make him proud.

Cara's mom

have sex with my boyfriend, sit outside, rub against corners of things to get a decent massage, make fun of people, pluck my eyebrows, and go to empty car garages and scream "vagina" at the top of my lungs. (I've really done this. It's quite therapeutic and liberating.)

What are your favorite musical groups /artists? Indigo Girls, Tupac, Sarah McLachlan. I wish I didn't, but I love the Backstreet Boys. Paul Simon, Janis Joplin, Outkast, Britney F**king Spears (she's hot).

Describe a typical Friday or Saturday night: One night's usually with the girls. One night's spent with Jared.

Other than your boyfriend or girlfriend, who is the most important person in your life right now? Tyler. My best girlfriend since I was 5. She goes to UVA, so we have a long-distance relationship. She's my soul mate. She's insanely independent. Tyler is beautiful, hilarious, and amazing.

What are some ways you have treated someone who has been important to you that you are proud of? One of my roommates and best friends has been dating my older brother for about two years now. Although people often think that the situation is potentially ideal, the truth is, it's weird as s**t and it drives me crazy. But I treat her so well. I work hard at making the situation as comfortable as possible.

What are some ways you have treated someone who has been important to you that you are embarrassed by, or wish you hadn't done? I talked s**t about one of my closest friends. I hate that I talk about her. I hate that I not only permit it, but encourage those around me to do the same. I'm

I like to believe that

confused that I can really love her so much and she can drive me crazy. Maybe I talk so much s**t because I'm secretly jealous.

Describe your mother: She's a total hippie. She did not wear a bra for a decade. Recently she refused to drive a car my dad bought her because it had a leather interior, which she deemed unnecessary. She's also like the Incredible Hulk, she's so strong.

Describe your father: A fuzzy peach, he's warm and wonderful, loving, thoughtful, and sometimes cries when things touch him. My dad's sort of an absentminded professor, too. He's brilliant yet often doesn't know how to answer questions like "How are you?"

If you have any brothers or sisters, are you close? How would you describe your relationship with them? Jeff and I are really different. He's a speechwriter for Al Gore and was hired right out of college. He's brilliant and amazing but pretty straight. We get along well, but we're not that close. Barrie is amazing, 14 going on 30. We're very close. When my family moved to St. Louis, I followed them for college because I know Barrie considers me kind of a mother.

What is the most important issue or problem facing you today? What the f**k I'm doing next year.

Do you believe in God? Are you religious or spiritual? I believe, or at least I like to believe, that there's someone up there. But I'm not religious at all. I'd much rather put my faith into other people or myself before laying it all down for some-thing that may not exist. I go to temple on the high holidays because I'm proud.

What are your thoughts on people who have a different sexual orientation from you? Good for them.

Do you have habits we should know about? I eat s**t off the floor. I use tester lip-sticks and I don't care about germs. I crack my knuckles. I pick at things.

What bothers you most about other people? Bad moods piss me off. F**k moodiness. Don't take your s**t out on other people who have nothing to do with it. It's unfair and selfish.

How do you handle conflicts? Do you feel that this approach is effective? I avoid them often, which is lame. But once they are unavoidable or in my face, I get excited. I yell. I make good points and get heated. It can be fun.

If you could change one thing about how you look, what would that be? I'd like to be taller. Maybe a different nose. I wish I had better legs, and big boobs would be nice. Not huge, but big. S**t, that was more than one.

If you could change one thing about your personality, what would that be? I wish I had balls (e.g. I wish I didn't avoid conflict).

If you had Aladdin's lamp and three wishes, what would they be? I wish Al Gore was President (my brother would be employed, too). I wish that my family still lived in Boston and especially that Barrie, my little sister, was happy. I wouldn't mind being cast on *The Real World*. Or, a chocolate Lab puppy. (I feel pretty selfish. Shouldn't I be wishing to end world hunger or something?)

there's someone up there.

CARA'S FAVORITES

Cocktail: Captain [Morgan] and Coke

Breakfast: IHOP pancakes

Fast-food item: McDonald's cheeseburgers

Cuisine: Japanese

Scent: Tribu, an old-school (discontinued) Benetton fragrance

Car: If the Infiniti QX4 came in a stick, V-8, that'd pump my 'nads

Brand of clothing: Can we dream? Gucci

Item of clothing: Seven jeans, Earl leather pants

Accessory: Green vintage necklace

Sneakers: Old-school Adidas

Magazine: *Out* with Chris on the cover

Book: *To Kill a Mockingbird*

Movie: *The Breakfast Club*

Television show: *Seinfeld, Sex and the City, Friends, Will and Grace, Family Ties*

Hour of the day: 4:20

Song to do karaoke to: Makes me uncomfortable

Actor: Ben Affleck

Actress: Gwyneth Paltrow

Cartoon character: Maggie Simpson

Sports team: Boston Red Sox

First date: Drinks, a Cardinals game, the symphony...not all in one night

Outfit to sleep in: Calvin Klein pajama pants and tank top

Video game: Donkey Kong on Atari

In The House

Who was the...

Best dressed: Aneesa, maybe Chris

Worst dressed: Kyle

Best dancer: Aneesa

Worst dancer: Chris

Best cook: Keri

Worst cook: Tonya (with butter)

Most hygienic: Chris

Least hygienic: Kyle

Why Cara Was Cast

Anthony Dominici: Cara was cast because she was funny and has a mouth on her. We were a little hesitant because we knew she wanted to be an actress—it was what we call a red flag in casting—but her personality won out in the end.

Kenny Hull: Cara immediately tickled our collective funny bone because she was just so honest and blunt and interested in seeing the humor in things. She was very honest about her insecurities, fun to talk to, and extremely smart and witty. She brightened up the room with her smile. Her home tape wasn't incredibly remark-able, but we could tell from the tape how well she interacted with her roommate and that was interesting to us. They were clearly having a blast together. Sometimes that's all we look for, how a cast member acts with others. In Cara's second inter-view, she talked a great deal about sex. She was still seeing Jared at the time, so that was an interesting issue. She recounted her Ali love spat and how Jared and Ali hated each other. No matter what she was saying, she was always able to spin the conversation in a delightful way.

Most diligent: Kyle

Biggest procrastinator: Aneesa

Best mannered: Theo

Worst mannered: Aneesa

Best attitude: Chris

Worst attitude: Can't think of anyone

Best in the morning: Tone-Lōc Tonya

Worst in the morning: Aneesa, but only for a moment

Most Overused...

Item of clothing: Aneesa's green Nordstrom shirt

Expression: Neven

Excuse for not cleaning: "Someone else will do it."

Line used by someone to get into the Real World house: "Can I see the house?"

when I get hungry, I get bitchy. It's interesting and entertaining.

Kyle

Casting Q & A

How did you first apply? They did an open call at Princeton. My friends and I were thinking, *The Real World! What a gas.* I went to one of those cattle calls. I was thinking it was ridiculous. Mary-Ellis Bunim interviewed me. It was Valentine's Day, and my girlfriend and I were having some problems. I told her, "We're probably going to go and see *Hannibal.*" That made her laugh. After the interview, I got pulled aside and asked to write an application.

Were you a *Real World* watcher? We never had cable. I grew up without Nickelodeon, nothing. It wasn't until college that I watched the show. My roommates and I would sit around making fun of it.

Which is your favorite cast and why? The first full episode I saw was the bitch-slap one from Seattle. That's the only season I really watched.

Describe the home video you submitted: I kept it simple. My video was me walking around campus and messing around with my friends. I didn't try to be a crazy exhibitionist. I'm really not an exhibitionist.

What did you think when you flew to L.A.? On the plane to L.A., I was thinking, *I'm going to dominate this interview.* Going to L.A. was the turning point in the casting process when it went from being a joke to being serious. I started to go after it like a job.

What did you wear? Very casual stuff. Collared shirt and shorts. Flip-flops. My mom told me to wear blue, because my eyes are blue, so I followed her advice.

Any highlights from your interview? It was an aggressive in-your-face interview. First they'd be in my face asking me what it was like to lose in football. Then they would try and change it up and get me telling dirty jokes. Meanwhile, my blood would still be boiling. But basically I thought I nailed them. I kinda knew it was a done deal. I knew I'd kicked a** in my interviews.

Where were you when you found out you got on *The Real World?* I was in the backyard doing gardening and landscape work. I had the cordless out on the porch. I was happy, but I was businesslike. I just felt it was meant to be. It was a combination of fate and confidence.

Who was the first person you told? My stepmom was at the house at the time. I called my mom and my best friend and Nicole and then I didn't talk about it much after that. I'd hang out with friends at the local watering holes and they'd be like, "What are you doing after graduation?" I just wouldn't tell them.

Did you ever think, *What have I gotten myself into?* I was in Chicago before the show started, and maybe I'd have thought that if I'd gone and checked out the house and stuff. I'm glad I didn't.

What did your family/friends/boyfriend/girlfriend think? My family was really excited. There was no *"Don't say this, don't do that" stuff.* They were proud of me and excited for me. They trust that I'm a quality person. It was all hugs and smiles. Nicole was very, very happy for me, because she knew I wanted it. My friends were like, "Kick a**, man. That's awesome."

How did you prep to be on *The Real World?* In the superficial sense, I bought some new clothes. I didn't get my hair styled or anything. It was a lot more mental preparation. I wanted to walk in there and be Superman and just kick a**.

First and middle name: Kyle

Age: 22

Presently living in: Princeton, New Jersey

Parents: Georgia and Robert

Siblings (names and ages): Ashley 24, Casey 18, Austin 10, Christopher 1

What is your ethnic background? Caucasian

Name of high school: Stevenson High School

Name of college (years completed and majors): Princeton University, English Major, 3 years completed

Other Education: —

Where do you work? Describe your job history: Spent summers with ad agencies and production companies.

What is your ultimate career goal? Financially, to reach a point where I can provide my

CASTING PREFERENCES

Read books: Love to. There's nothing more satisfying than finishing one

Sleep 8 hours: Either much less or much more

Watch television daily: News, sports. I hate sitcoms

Shop: It can be fun. I like food shopping

Go out/party: I like everything—bars/clubs. Beer/liquor

Spend time with friends: These days, pretty much all we do is laugh and drink

Spend time alone: Frequently. I can be a very solitary person sometimes

Balance work/study: I've always been pretty good at it

Talk on the phone: Only as a necessary means. I'm so much stronger in person

Cook: I'm not bad. I want to cook my wife meals someday

Clean: When I want to, which is rare—ask my roommates

Write e-mail: It's so much easier to receive them, isn't it?

Read newspapers: News section, sports section, financial—in that order

Play with animals: I don't know—who cares?

State opinions: I'm a strong communicator, but opinions must be stated with tact. Some don't understand this

kids and wife with whatever they need. Individually, to find SOMETHING lucrative that I'm happy doing.

What kind of pressure do you feel about your future? Right now I have a lot of pressure. As a Princeton senior with an uncertain future, I feel it every day. My parents aren't pressuring me. Maybe they should be.

What artistic talents do you have (music, art, dance, performance, film/video making, writing, etc.)? How skilled are you? I've acted in several plays on campus. I've been a lead singer in a rock band. Done tons of creative writing.

What about you will make an interesting roommate? I always have a lot on my plate, and therefore have a lot to share. Particularly through college. I've felt that if I'm only here four years, I should do as much as possible. As a roommate, I am also a very good listener. A rare trait, I think.

How would someone who really knows you describe your best traits? They'd say I'm VERY caring with those I love. I'd rather give a gift than receive. I'm also very pensive, which accompanies my ability to listen and be therapeutic to loved ones in that way. I'll admit when I'm wrong.

How would someone who really knows you describe your worst traits? Too often I try to make everyone around me happy. To be the "peacemaker," especially with my family.

Do you have a boyfriend or girlfriend? How long have you been together? Where do you see the relationship going? My girlfriend of two years, the love of my life, and I just broke up. We both (particularly me) needed to grow up and have many more experiences if we're going to end up together. The break was VERY emotional and still is. This wound is fresh.

Ask opinions: Frequently. It's one of the best ways to be a leader

Confide in your parents: Whether initially, or when all else fails, ultimately the best way to go

Volunteer: I don't know. I'm more of a Gators fan

Procrastinate: My college should be renamed Procrastinate State

Eat: Usually whatever, whenever. I really like sushi

Get drunk: Really fun. But only for people over 21, right?

Diet: I'm active enough to burn off what I eat. Plus, I'm not all caught up with my body image

Vote: Republican

Cry: Somewhat often. I'm pretty sensitive

Laugh: A lot, but it's even better to make others do so

Instigate: Abso-friggin-lutely. And proud of it. Heheheheheh

Cinema: At least a few times a month

Theater: Love it, especially in New York

Concerts: The louder the better

Clubs: When I'm in the mood, definitely

Parties: What's not to like? Party on, Garth

Surf the Web: Usually only O-Town.com

Heard in Casting

Kyle: My girlfriend, Nicole, told me that I need to do the show if I get on, that I need to have other experiences. She was like, "I know you haven't dated a lot of women before me." I said to her point-blank, "Nicole, do you realize that you could be sitting there watching MTV and watching me make out with some girl!" I told her she had to understand that. I told her that her friends and family would see it. And they're all going to talk about it.

What qualities do you seek in a mate? Very strict honesty. No lying about anything. Share everything. Be my best friend.

How important is sex to you? Do you have it only when you're in a relationship or do you seek it out at other times? I did not lose my virginity until 20, with my aforementioned girl-friend, true love. I am VERY proud of this; I'll tell my son someday. I've never been promiscuous; I think it's just because I set my standards so high.

Describe your fantasy date: Simple, in a comfy setting with great food, a little wine, and lots of talking. I'm a romantic.

What do you do for fun? I've always been very friend-associated. Guys' nights out rule. Even if I'm not single, it's great to go out with my buddies and flirt, drink, laugh. Good clean fun.

What are your favorite musical groups/artists? The Doors, Pearl Jam, Metallica, many others.

Describe a typical Friday or Saturday night: Either with the guys on the town, or curled up with girlfriend and a movie.

Other than your boyfriend or girlfriend, who is the most important person in your life right now? My father. He has been through everything: divorces, kids, business. At this crucial point in my life, I look to him more than ever. He's an amazing father.

What are some ways you have treated someone who has been important to you that you are proud of? My 10-year-old brother. I'm God to him. I'm so proud of him it literally brings tears to my eyes.

What are some ways you have treated someone who has been important to you that you are embarrassed by, or wish you hadn't done? I wish that, when I was growing up, I was nicer to my little sister. I teased her a lot and gave her a hard time, which she has enough of without me. I still regret this.

Describe your mother: One part is a motor-mouth (loving) who calls me at school more than I'd like. One part is a very deep person who has been through a lot and has scars because of it. I love her.

Describe your father: A kid who still lives vicariously through my college experiences. The smartest person I know.

If you have any brothers or sisters, are you close? How would you describe your relationship with them? I've spoken about my little bro. My 18-year-old sister and I have never been close; she got lost in the shuffle of the divorce.

What is the most important issue or problem facing you today? What do I want to do with my life? It seems to be all I can think about, but I still don't know.

Do you believe in God? Are you religious or spiritual? I'm religious, but not overtly so. Church on Christmas, Easter, etc.

What are your thoughts on people who have a different sexual orientation from you? No problem at all. Being involved in different activities has exposed me to this. I think it's intriguing.

Do you have habits we should know about? No.

What bothers you most about other people? Rudeness and inability to communicate. People graciously speaking their minds are so attractive to me.

How do you handle conflicts? Do you feel that this approach is effective? Rationalize, consider all options. Sometimes you've got to ride your emotions, but calmly addressing the problem usually works for me.

If you could change one thing about how you look, what would that be? I'd like to be a little taller. I think real masculinity requires six feet, and I'm a shade under.

If you could change one thing about your personality, what would that be? That I could tell people I love them more. I've always felt awkward about it. Even with my parents.

If you had Aladdin's lamp and three wishes, what would they be? Health for my family, a loving marriage, and healthy children. Something eccentric.

been promiscuous.

what do I want to do with my life?

Cocktail: Jack on the rocks

Breakfast: Jack on the rocks

Fast-food item: Arby's sandwiches

Cuisine: Mexican or Japanese

Scent: Carolina Herrera 212

Car: Jeep Wrangler

Brand of clothing: Sisley

Item of clothing: My leather jacket

Accessory: Playstation 2

Sneakers: Adidas

Magazine: *Newsweek*

Book: *Paradise Lost*

Movie: *Boogie Nights/Seven/True Romance/*too many others to name

Television show: *Supermarket Sweep*

Hour of the day: Pre-partying hours

Song to do karaoke to: Any hard rock song, Stone Temple Pilots

Actor: Christian Bale

Actress: Raquel Welch

Cartoon character: Ralph Wiggum

Sports team: Chicago Bears

First date: NBA game

Outfit to sleep in: Birthday suit

Video game: Tecmo Bowl

In The House

Who was the...

Best dressed: Chris. Appearance was everything to Chris, and his clothes reflected that. I won't lie, I borrowed some of his stuff from time to time. He had some damn nice things.

Worst dressed: Everybody dressed really well. I think that Tonya relied pretty heavily on Cara's clothes sometimes, but so did Aneesa. Tonya also showed too much skin sometimes.

Best dancer: Aneesa. She was just sexy and hilarious. I loved dancing with Aneesa after a few drinks.

Worst dancer: Chris. Some people may say me, but I've got Chris beat. Guaranteed.

Best cook: Keri was really the only one who cooked, and she was pretty good. But, everytime she cooked something she would say that she messed it up and it was horrible. Every time.

Worst cook: Tonya. She started a mini fire on the stove simply attempting to melt butter. Genius.

Why Kyle Was Cast

Anthony Dominici: If we were going to have the white all-American man, why not have one who's in touch with his emotional side and who's really smart? Women in the office thought he had classical leading-man looks, so I'm sure that played a big part as well.

Kenny Hull: We went back and forth with Kyle. It all had to do with Nicole. He kept telling us he was going to break the cord with Nicole and get ready to party and rock Chicago. We didn't really believe him.

We'd seen that happen before. Noah and Dan from the Northern Trail season of *Road Rules* had both told us they were going to break up with their girlfriends, and then didn't. We try not to cast people in serious relationships, because relationships limit how much you can get to know people. Kyle wasn't lying about wanting both to cut the cord and live life to the fullest. And, in fact, it was the conflict that made his story so interesting.

Most hygienic: I guess Chris. Again, aesthetics and appearances were very important to him.

Least hygienic: I don't think anybody was unhygienic. Some people may say me, but I was just messy. Everybody kept themselves clean.

Most diligent: Probably me. I was pretty committed to whatever we were doing as a group, whether it was work or going out.

Biggest procrastinator: Aneesa. She was a pretty lazy girl.

Best mannered: Cara. She's the perfect girl to take home to your parents. Her social skills and manners are impeccable.

Worst mannered: Probably Aneesa or Theo. Theo used to sleep at the table in restaurants and Aneesa would spend most of the time away from the table smoking or on a cell phone.

Best attitude: Probably Cara. Her ongoing slogan when things went wrong was, "We're OK, we're OK."

Worst attitude: Theo, Cara, Keri, and I usually had pretty good attitudes. It's a toss-up between Aneesa, Chris, and Tonya. I'd put my money on Aneesa or Chris.

Worst in the morning: Aneesa. If someone didn't wake her up, she just wouldn't get up. She wasn't bitchy or anything, just really lethargic and always in slow motion.

Best in the morning: Tonya. We often woke up to the rapid pitter-patter of her feet in the morning. Of course, she had so much energy in the morning because she never went out at night. I suppose the rest of us would have been more energetic if we went to bed at 10 PM every night.

Most Overused...

Item of clothing: Any of Cara's clothes. One night we went out to dinner and she pointed out that all three of the other girls were wearing her clothes. She was just so gracious that I think she got a little taken advantage of.

Expression: Anything pertaining to how lame we thought our jobs were or how much our trip sucked.

Excuse for not cleaning: "Cara's already doing it."

Line used by someone to get into the Real World house: "I know Theo," by any female.

Tonya

Casting Q & A

What made you apply? I was in Portland and I heard about a *Real World/Road Rules* open call. I am really active; I wanted to do *Road Rules*. Justin and I had broken up and I was looking for a ticket out of Walla Walla. I showed up in sweats. I figured anyone could look pretty. I didn't take it seriously. As if they'd choose someone from Walla Walla, Washington! I went to the open call and continued to pursue school and didn't give it much thought.

Were you a *Real World* watcher? I'd seen it a couple of times. People were always saying I'd be hilarious on it.

Which is your favorite cast and why? Once I made the show, I started watching old episodes. I don't know them well enough to have a favorite.

Describe the home video you submitted: It was very fun. I showed them a small clip of me teaching rock climbing—that's my sport!—and teaching swimming. I showed them a little bit of Walla Walla. I thought these city people would be floored. I was being sarcastic and funny and was really in my realm.

What did you think when you flew to L.A.? It was exciting flying to L.A. The industry, the hotels, the whole thing for me was very exciting. I used the interviews to analyze myself. They let me look at myself deeper. It was a nice period of reflection.

What did you wear? After wearing sweats to the first one, I wanted them to see my cutesy side, that I was capable of getting decked out. I was casual and natural, but cute.

Any highlights from your interview? I was really honest. I told the interviewer I'd been struggling with an eating disorder. It felt really good to talk about and I figured that they'd find out anyway. By L.A., I thought they had me pegged.

Where were you when you found out you got on *The Real World*? I was in Pullman, Washington, with Justin. We'd gotten back together at that point. I was by myself when I got the phone call. Justin walked in five minutes after I got the phone call and we just cried. We were so happy and so in love and throwing any wrench into it was scary.

Who was the first person you told? Justin, of course. I didn't really call people. That's what's painful about my life. I don't have a lot of people to call.

Did you ever think, *What have I gotten myself into?* Not until I got to Chicago.

What did your family/friends/boyfriend/girlfriend think? It only mattered what Justin thought, and he was excited for me but upset to be separated.

How did you prep to be on *The Real World*? I'm a dork. I write down five goals a month and I try to live by them. That's what I did. First on the list was "Be honest."

First and middle name: Tonya

Age: 21

Presently living in: Walla Walla, Washington

Parents: Unknown

Siblings (names and ages): Unknown

What is your ethnic background? Caucasian

Name of high school: Walla Walla High School

Name of college (years completed and majors): Walla Walla Community College. Currently a junior in the Nursing Program

Other education: Working on my EMT certification

Where do you work? Describe your job history: YMCA: swim instructor, lifeguard, rock climbing instructor. Community college: Student athletic trainer. Local photography company: Model, processing film.

I write down five goals a month

CASTING PREFERENCES

Read books: Rarely

Watch television daily: Never, but I just got cable so it's a new experience

Shop: I'd rather be in the gym

Go out/party: When Justin is studying

Spend time with friends: A lot, since Justin is always studying

Spend time alone: Most of the time

Balance work/study: No balance, not studying right now, it's driving me nuts

Talk on the phone: Too much since the show

Cook: All the time

Clean: All day once a week

Write e-mail: Never

Read newspapers: Never

Play with animals: Depends (does Justin qualify as an animal?)

State opinions: All the time, probably too much

Ask opinions: Rarely; if you matter, then maybe

What is your ultimate career goal? I know that I will be someplace in the medical field. I am aiming toward emergency medicine. However, I am open-minded.

What kind of pressure do you feel about your future? I know most of the pressure I feel originates from being a foster child. Going to college and being successful is, I think, out of the norm for individuals who were raised in the system. I've always felt I had to work a little harder, study a little longer, and push myself as far as I could. This comes from trying to prove wrong all those people who said, "She's just a foster kid."

What artistic talents do you have (music, art, dance, performance, film/video making, writing, etc.)? How skilled are you? Music is the center of me. It's how I relax, release my energy. I sing for my local community members. Typically, I sing the national

anthem at a ball game or at the fairgrounds. I was born to be a performer.

What about you will make an interesting roommate? I am so energetic. I enjoy doing a large variety of activities. I've always been the leader of the pack, encouraging others to go out and try new things.

How would someone who really knows you describe your best traits? Energetic, goal-oriented, strongwilled, athletic, confident, loyal, independent.

How would someone who really knows you describe your worst traits? Short of death, I will stop at nothing when it comes to pursuing my dreams. I push myself way too hard. I'm very intense and I think I wear other people out.

Do you have a boyfriend or girlfriend? How long have you been together? Where do you see the relationship going? No, my standards are high and I'm not willing to

and I try to live by them.

Confide in your parents: That's a negative

Volunteer: Not as much as I should

Procrastinate: Don't

Eat: Daily

Get drunk: Rarely, 'cause I act stupid when I drink

Diet: I don't do diets

Vote: Vote what?

Cry: A lot, I'm a woman

Laugh: A lot

Instigate Sex?: A lot

Cinema: Rarely

Theater: Never

Concerts: No

Clubs: What clubs? Bars maybe.

Parties: High school…

Surf the Web: I'd rather be outside, but mostly I'm computer illiterate

Tonya: This was the first Thanksgiving and Christmas I spent completely by myself. It was hard. I just didn't want to be with somebody else's family. The last time I saw my mom was my freshman year in college. I received a random call saying she was in the hospital. I drove down to Portland and saw her in the hospital. That was the last time I saw her, and I don't know if she made it. I don't know if she's dead or alive. I don't think I want to know. I think my dad's alive, but it doesn't matter.

settle. I've had the love where it took my breath away and I can't feel that way again with someone else. I won't. I am so independent, I find it hard to find guys who enjoy letting me be me and do my own thing. I love people from afar. I know that stems from a painful past with no family.

What qualities do you seek in a mate? Confident, outdoors man. Athletic, loyal, funny.

How important is sex to you? Do you have it only when you're in a relationship or do you seek it out at other times? Sex is extremely important to me. I have had it both in and out of the context of love. I strongly believe it's much more meaningful when two people really love each other.

Describe your fantasy date: Throw on a baseball cap and some jeans. Grab a small lunch and go on an awesome hike. Get all sweaty and then jump in a lake somewhere!

What do you do for fun? Rock climb! Karaoke. Running is my passion. Snow ski, water ski, sing, dance.

What are your favorite musical groups/artists? Dixie Chicks, Faith Hill, Tim McGraw.

Describe a typical Friday or Saturday night: Unfortunately, my Fridays consist of studying my a** off. I take one day out of the weekend to do something with my friends and, normally, I find myself dancing.

I think I've endured too much

Other than your boyfriend or girlfriend, who is the most important person in your life right now? My best friend, Nathan. He's a release from my world. I don't have to perform for him. He lets me be me and it's good enough.

What are some ways you have treated someone who has been important to you that you are proud of? I'm loyal to people who are important to me.

What are some ways you have treated someone who has been important to you that you are embarrassed by, or wish you hadn't done? I think I have taken a lot of important people in my life for granted. I didn't realize it until later in life. I wish I could go back and express how thankful I am.

Describe your mother: Never had a mother or adult figure in my life.

Describe your father: Never had a father or adult figure in my life.

If you have any brothers or sisters, are you close? How would you describe your relationship with them? —

What is the most important issue or problem facing you today? Deciding to transfer to Arizona State University and how to pay for school since I have no family support.

Do you believe in God? Are you religious or spiritual? Yes and yes.

What are your thoughts on people who have a different sexual orientation from you? I am OK with it as long as they respect me.

Do you have any habits we should know about? Nope.

What bothers you most about other people? Insecurities.

How do you handle conflicts? Do you feel that this approach is effective? If I'm in the midst of a conflict, I remain calm.

If you could change one thing about how you look, what would that be? I look like a little girl. I hate it!

If you could change one thing about your personality, what would that be? I push myself way too hard. I need to listen to my body more. My brain works faster than my body sometimes.

If you had Aladdin's lamp and three wishes, what would they be? Pay my way through medical school. I don't believe that what doesn't kill you makes you stronger. I think I've endured too much in such a short life span. I would like to forgive and forget a lot of it. I recently had a close friend's mother die of cancer and I can't for the life of me help him. I wish I could have changed that situation.

in such a short life span.

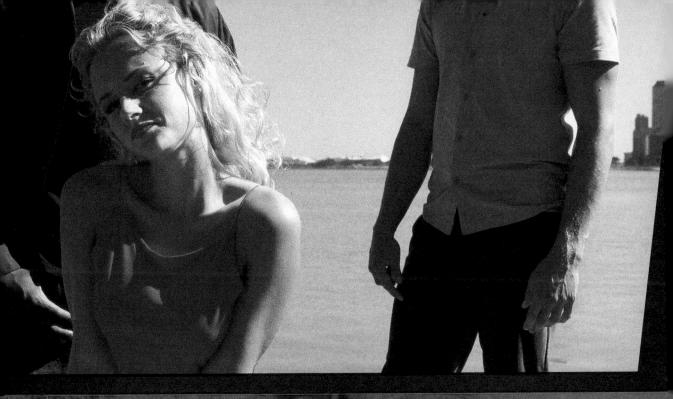

TONYA'S FAVORITES

Cocktail: Red Bull vodka

Breakfast: Scrambled salsa eggs and blueberry pancakes

Fast-food item: McDonald's plain Cajun chicken

Cuisine: Who's that?

Scent: Cinnamon

Car: Big red truck

Brand of clothing: Ones that fit

Item of clothing: Fleece socks

Accessory: Watch

Sneakers: Air Max

Magazine: *Muscle and Fitness*

Book: *Emergency!* by Mark Brown, M.D.

Movie: *Dirty Dancing*

Television show: *Life in the Trauma Room* (The Learning Channel)

Hour of the day: 4 AM

Song to do karaoke to: "Goodbye Earl" by Dixie Chicks

Actor: Richard Gere

Actress: Julia Roberts

Cartoon character: I'm way too mature to watch cartoons

Sports team: No favorite sports team (Justin suggests the Seattle Mariners)

First date: Justin and I rock-climbing

Outfit to sleep in: Fleece pajamas when I can't find my skin

Video game: Super Mario Bros.

In The House

Who was the...

Best dressed: Me

Worst dressed: Aneesa (or not dressed)

Best dancer: Aneesa (definitely not Chris)

Worst dancer: that be Chris

Best cook: Keri (good ol' southern cookin')

Worst Cook: Me (setting the stove on fire was my downfall)

Most hygienic: Me

Why Tonya Was Cast

Anthony Dominici: There's something all-American about Tonya. She's the most relatable cast member as far as who she is, where she's from, and where she wants to get to. She's a down-home kinda girl.

Kenny Hull: Our first interview with Tonya was riveting. Without batting an eyelash, she talked about horrible things she'd been through. She was almost accessible to a fault. She's an amazingly interesting person. She really rocked our world in casting. We did a follow-up with her when she ran Pamela Anderson–style on the beach. On the surface, it seemed like we picked Barbie, but underneath was this girl getting ready to unravel and then ravel up again. She was undeniable. She was going to guarantee the show conflict, sexuality, and something unique. She's different—and that's a good thing. She was a great choice.

Least hygienic: Kyle (How many times in a row did he wear those boxers?)

Most diligent: Me

Biggest procrastinator: Aneesa

Best mannered: Cara

Worst mannered: Theo

Best attitude: Keri

Worst attitude: Theo

Best in the morning: Me

Worst in the morning: Theo

Most naked: Aneesa

Most Overused...

Item of clothing: Kyle's boxers

Expression: "Neven" or "Peace-lovin' stomas"

Excuse for not cleaning: "That's a maid's job"

Line used by someone to get into the Real World house: "I'll get naked..."

> On the surface, it seemed like we picked Barbie, but underneath was this girl getting ready to unravel and then ravel up again.

CASTING

131

I really didn't think I was going to get it. I wasn't a stereotypical anything. I thought they would want someone more normal, and I don't feel very normal.

Keri

Casting Q & A

How did you first apply? One of my friends, this guy Joe, came over and told me, "We're going to try out for *The Real World*." I was still stinky from the night before. We went to Burger King to pick up breakfast, and then went to tryouts. It was 10 AM and I started to get nervous. The casting call was at a bar. I had a screwdriver. They put us in groups and asked us questions. I think they liked me because I insulted a girl in our group, then closed my mouth and lit up a cigarette.

Were you a *Real World* watcher? I watched the first couple of seasons. I watched Seattle and Boston. I didn't really like the New Orleans cast. They didn't represent New Orleans at all. There was no one from there!

Which is your favorite cast and why? My favorite one was definitely New York. It was so new and they had no idea what they were getting into. I sort of imagined myself on it, but I figured I'd be waiting until I was 21 so I could drink with the roommates.

Describe the home video you submitted: It was early in the morning. I took the camera to the Red Eye Grill where I worked. I ended up going out that night and getting trashed. I sent it the next day.

What did you think when you flew to L.A.? I was shocked I'd made it that far.

What did you wear? Black pants and a gray tank top. I wanted to be able to cross and uncross my legs. I wanted to look nice, of course, but I was more dressed for comfort.

Any highlights from your interview? They want to know everything about you. Sometimes it's easier to unload secrets on a stranger. They weren't going to judge me.

Where were you when you found out you got on *The Real World*? They told us we'd find out on June 28. My birthday is June 29. My parents stayed home to wait with me. When they called, they said, "Happy birthday! You made it!" We cracked open a bottle of champagne and ate a really nice dinner and that was it. I really didn't think I was going to get it. I wasn't a stereotypical anything. I thought they would want someone more normal, and I don't feel very normal.

Who was the first person you told? My mom and then my dad. We were all screaming. It was the best birthday present ever.

Did you ever think, *What have I gotten myself into?* No, I didn't think that until the show was almost over.

What did your family/friends/boyfriend/ girlfriend think? The guy I was dating didn't like that I was leaving him, but everybody else was really supportive and excited. My parents told me not to get naked and then my 95-year-old aunt was like, "Get naked, Keri! They like that." My parents also told me not to kiss any girls. They know they can't regulate me, they've been living with me too long.

How did you prep to be on *The Real World*? I went to school, canceled the lease on my apartment, moved out, painted it, then packed for three days. I did a little shopping, but not too much. I got my hair highlighted again, but I was in need of that anyway.

First and middle name: Keri

Age: 21

Presently living in: New Orleans

Parents: Rachel and Michael

Siblings (names and ages): Mike 25, Kyle 10, Lori 8

What is your ethnic background? Welsh, French, Spanish, Mexican

Name of high school: Archbishop Blenk High School

Name of college (years completed and majors): Loyola University. Major: Psychology, Minor: Biology and Criminal Justice

Other education: —

Where do you work? Describe your job history: Bartending, lifeguard, eye surgery clinic, employment researcher

What is your ultimate career goal? I would like to go into Criminal Psychology or the

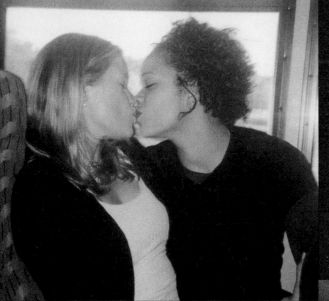

My parents also told me

CASTING PREFERENCES

Read books: I love nonfiction/true crime

Sleep 8 hours: I sleep a lot, but in small increments

Watch television daily: No, I watch movies

Shop: Only when I need something

Go out/party: Occasionally. I'm up for almost anything

Spend time with friends: Every day

Spend time alone: Every day

Balance work/study: 8-8-8

Talk on the phone: Only when someone calls

Cook: I'm a good cook, but my fridge is empty

Clean: On Fridays

Write e-mail: Every day

Read newspapers: Sports, Living section, headlines

Play with animals: When I'm in their presence, yes

State opinions: When I'm in a discussion, yes

Ask opinions: When I'm in a discussion, yes

Behavioral Sciences Department of the FBI. If not, I'll go to Law School and do criminology.

What kind of pressure do you feel about your future? I feel pressure from myself. Since I was small, my parents have always stressed how proud they are of me no matter what I was doing, as long as I was happy. They gave me the strength to be myself.

What artistic talents do you have (music, art, dance, performance, film/video making, writing, etc.)? How skilled are you? I write. I've been writing as long as I can remember. I love the way it clears my mind.

What about you will make an interesting roommate? I used to live with seven girls in a dorm room. It really helped me understand other people and how to accept them for who they are. I also know how to share. One bathroom with seven girls!

How would someone who really knows you describe your best traits? I'm honest and trustworthy. I would do anything for my friends and family. I tend to be happy always. I am a very good judge of character. I'm very logical and observant.

How would someone who really knows you describe your worst traits? I procrastinate, I sleep a lot, I have mood swings. I answer every question even if I don't know the answer, but I don't consider myself a know-it-all.

Do you have a boyfriend or girlfriend? How long have you been together? Where do you see the relationship going? I am recently single (again). I was hurt about three years ago and I don't want relationships even though I really do.

What qualities do you seek in a mate? I never want to stop laughing. I want someone who likes to party when the time is right and chill when it's not. I would love to find someone that's a good balance of myself.

not to kiss any girls.

Confide in your parents: Yes, they are wise

Volunteer: On holidays

Procrastinate: Every day

Eat: All the time

Get drunk: Once a week

Diet: Never

Vote: Always

Cry: It takes a lot, but it happens

Laugh: Always

Instigate: Not really

Cinema: I go about 2x a month or more

Theater: Only when I'm really interested

Concerts: Love live shows

Clubs: When I want to dance

Parties: When I can go

Surf the Web: About 2–3 times a week

Keri: The other day I was sitting there, just thinking, and it dawned on me, *Damn it, I'm an adult.* I gotta say, sometimes it's hard. There are some days I'm extremely happy, so glad to be alive. I guess you could say I have mood swings, because there are other days when I'm like, "Damn, this sucks." I'll be pissed off at the world, mad. I do relaxation breathing to make myself feel better. I don't care if I'm in the middle of class, I'll start breathing.

How important is sex to you? Do you have it only when you're in a relationship or do you seek it out at other times? Sex is a good thing. Relationships should not be based on sex, but it doesn't hurt, either.

Describe your fantasy date: Batting cages, horseback riding, movies, but not the typical movie-and-dinner routine or a wine-and-dine. I want to have fun.

What do you do for fun? I go out, I work (I love my job), I love to dance, I go to the park, I work out by playing baseball with my little brother. I love road trips and I love hanging out with my friends from Memphis.

What are your favorite musical groups/artists? I like all kinds of music. I love Bill Withers, Van Morrison, Fleetwood Mac. I love '80s music and '70s classic rock.

Describe a typical Friday or Saturday night: I work one of the nights. The other my friends and I will get dressed and go to uptown bars or the downtown area to dance.

Other than your girlfriend or boyfriend, who is the most important person in your life right now? My mother. She is my rock. We fight like sisters and I trust her with everything. She does not know about my sex life, though. I would have to say that she is one of the main reasons I am this way. My family in general means so much to me.

What are some ways you have treated someone who has been important to you that you are proud of? My little brother and I have a

There just has to be something

great relationship. He is so important to me. He was born when I was 11 so I helped raise him. He knows he can talk to me about ANYTHING. I am proud of myself for that.

What are some ways you have treated someone who has been important to you that you are embarrassed by, or wish you hadn't done? I sometimes wish I would be better at calling people back. I tend to make friends feel neglected.

Describe your mother: She is the kindest person, but she has a Spanish temper. She would give me anything, but she'll bring it up in a fight. She's the best mom, but only when she's in the mood.

Describe your father: An exact balance of my mother. He's a great businessman, very respected. He's dedicated to a task until he sits down, then it will never get done. He's a teddy bear at home, but at work he's strong.

If you have any brothers or sisters, are you close? How would you describe your relationship with them? I have two brothers and a sister. I'm much closer with Kyle. Mike and Lori and I are close.

What is the most important issue or problem facing you today? I worry about my little brother and sister. I got used to being there for them and I moved on. It's hard to let go.

Do you believe in God? Are you religious or spiritual? I believe in God. I'm a Catholic, and I don't know how I feel about that

right now. There just has to be something bigger out there that created this. It's too magnificent.

What are your thoughts on people who have a different sexual orientation from you? I don't care. As long as the person's nice it doesn't bother me. More power.

Do you have habits we should know about? Smoker, that's about it. I shower a lot.

What bothers you most about other people? Lack of common sense—I don't know what it is about having to explain myself over and over. That bothers me.

How do you handle conflicts? Do you feel that this approach is effective? I talk it out. It works because it helps us find a balance or compromise. When people yell they rarely hear the issue. I don't think that works.

If you could change one thing about how you look, what would that be? I want to have perfect teeth. I wish that I flossed more.

If you could change one thing about your personality, what would that be? I would not want to be so moody. I can be satisfied one minute and not satisfied the next.

If you had Aladdin's lamp and three wishes, what would they be? 1) To be happy all the time, Midas touch–like, when people touch me they are happy too. 2) I want my dad to be happy. He's always so stressed out and he watches out for us. 3) Paid-for credit card with no limit (I have to do something a little materialistic).

bigger out there that created this. It's too magnificent.

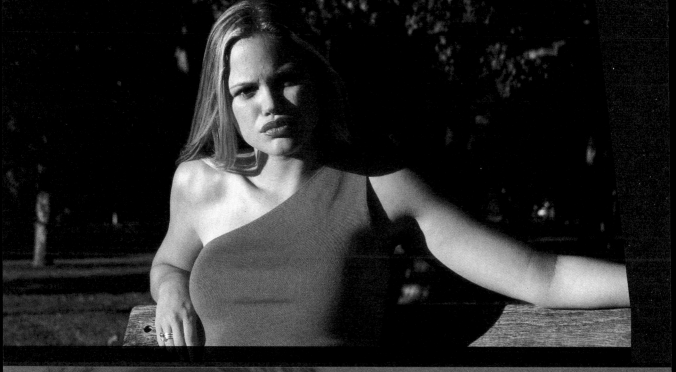

KERI'S FAVORITES

Cocktail: Jager shots or Captain [Morgan] and Coke

Breakfast: Smoothies from Smoothie King

Fast-food item: Arby's roast beef sandwiches

Cuisine: Italian/Cajun

Scent: Gucci Rush

Car: Volvo convertible

Brand of clothing: French Connection

Item of clothing: Jeans

Accessory: My rosary ring, given to me by my mom

Sneakers: Saucony

Magazine: *Maxim*

Book: *Harry Potter* or any James Patterson novel

Movie: *The Goonies*

Television show: *Jeopardy* and *The Sopranos*

Hour of the day: The hour that I nap

Song to do karaoke to: "Livin' on a Prayer," Bon Jovi, or "I Think We're Alone Now," Tiffany

Actor: Chris Farley (dead), Kevin Spacey (living)

Actress: Gilda Radner (dead), Parker Posey (living)

Cartoon character: Scooby-Doo or Homer Simpson

Sports team: New Orleans Saints

First date: Jason Shepard at an eighth-grade dance

Outfit to sleep in: Polka dot PJs

Video game: Ms. Pac-Man

In The House

Who was the...

Best dressed: Christopher

Worst dressed: Tonya (Also, Kyle wore the same thing a lot because he never washed his clothes)

Best dancer: Theo

Worst dancer: Kyle

Best cook: Me

Worst cook: The people who made ramen every day. That's not cooking.

Why Keri Was Cast

Anthony Dominici: Keri told us in casting that she could date five men at a time. She's carefree, ballsy. She has a guy's perspective on life, which is a funny thing to see in such a pretty girl. She's like the Cameron Diaz character in *There's Something About Mary*.

Kenny Hull: Keri turned the head of every boy in the casting department. She oozed sexuality and confidence. She was mysterious. She didn't say everything she was thinking. She was living her life for herself and having a good time doing it. Her home tapes were taken in bars. We could tell she was just rocking these bars in New Orleans. She brought energy to the room. In a city like Chicago, we thought she'd get into a lot of trouble, have a lot of fun, and take us on a wild ride.

Most hygienic: Tonya

Least hygienic: I don't know

Most diligent: Kyle

Biggest procrastinator: Aneesa (and me too)

Best mannered: Cara

Worst mannered: Theo (he fell asleep at the dinner table)

Best attitude: Cara

Worst attitude: Tonya

Best in the morning: Tonya

Worst in the morning: Me

Most Overused...

Item of clothing: Cara's scarves

Expression: "Who da?! What da?!"

Excuse for not cleaning: "I'm tired"

Line used by someone to get into the Real World house: "I'll take any one of you ladies on a date." "I just want to see your house."

She has a guy's perspective on life . . .

–Anthony Dominici

They screamed at me, "Don't get kicked off!" They thought I wouldn't last. My mom bet with my brother that I'd last two weeks and then come home.

Aneesa

Casting Q & A

How did you first apply? Someone in my psych class told me about an open call they were having downtown. The morning of the open call, I was beat. I had a stomach virus and my band Subtle Ground had performed the night before. I was so weak I could barely get up. Then when I got there and got on line, I realized I didn't have ID with me and some guy told me I needed it. Someone had to save my place on line so I could run home. The whole thing was so crazy, but I still made it. Sitting at the table with the other people auditioning, I thought, *I got this s**t.* I just had a feeling.

Were you a *Real World* watcher? I started watching when I was 14. I never imagined myself on it, but I liked it.

Which is your favorite cast and why? I liked Seattle and I liked Hawaii, of course. I loved Ruthie. Ruthie's lifestyle was a little too much for me. I hate drinking, so she and I wouldn't get along. She's cute, but looks can only take you so far when you have problems like that.

Describe the home video you submitted: It was horrible. It wasn't edited well. I made it at home and at school. I was being funny. It was stupid.

What did you think when you flew to L.A.? By the flight to L.A., I was thinking I pretty much had it. I thought I was meant for Season 11. I got back from L.A. and a friend said, "Congratulations." I said, "I didn't make it yet, stupid." She told me to take the congratulations now, so she didn't have to give them later. I guess she knew I was *Real World* material, whatever that means.

What did you wear? A shirt and jeans and a jean jacket, not a lot of makeup. I wasn't trying to present myself in any particular way.

Any highlights from your interview? I actually went to New York for an interview before I went to L.A. They tried to get me to cry. They put an empty chair next to me and asked me, "If your mom were sitting there, what would you say?" I was like, "She's not there. I'm not talking to an empty chair. Do *not* try and make me cry." In L.A. I was asked a lot of naughty questions. I ended up saying a bunch of dirty stuff. I'm glad there's no casting special. I'd be so embarrassed.

Where were you when you found out you got on *The Real World*? I was at home. I'd been told I'd get a call between 6 PM and 7 PM, and you know how it is, the phone rang at 6:59 PM. They were like, "Sorry to disappoint you...but you better pack your bags." I started screaming. I couldn't stop. They asked me if I was OK.

Who was the first person you told? My mom was listening on the other line when they told me. And then I called the Gap, so I could say, "I quit!"

Did you ever think, *What have I gotten myself into?* Well, I thought that, but it wasn't like I could do anything about it.

What did your family/friends/boyfriend/ girlfriend think? I didn't have a girlfriend at the time. My mom was warning me, "Don't mess up our family. Keep some things private." My friends were excited. They screamed at me, "Don't get kicked off!" They thought I wouldn't last. My mom bet with my brother that I'd last two weeks and then come home.

How did you prep to be on *The Real World*? I redyed my hair just to touch it up. I didn't do a lot of shopping. My mom refused to buy me anything new for the show.

ANEESA'S APPLICATION

First and middle name: Aneesa

Age: 19

Presently living in: Naberth, Pennsylvania

Parents: Rachel and Leayle

Siblings (names and ages): Robert 27

What is your ethnic background? Black, White, West Indian, and Portuguese

Name of high school: Lower Menton High School

Name of college (years completed and majors): Montgomery County Community College, Liberal Arts

Other education: —

Where do you work? Describe your job history: I work at the Gap. I have been a hostess. I was a camp counselor and a dancer and a vocalist for an entertainment company.

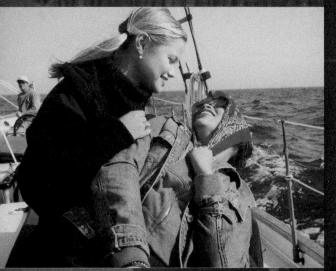

I'm real when it comes to

CASTING PREFERENCES

Read books: Sometimes

Sleep 8 hours: Not very often

Watch television daily: Nope

Shop: Often

Go out/party: Often

Spend time with friends: Often

Spend time alone: Not much

Balance work/study: Occasionally

Talk on the phone: All the time

Cook: Nope, I like to eat out

Clean: When I have to

Write e-mail: A lot

Read newspapers: Not really

Play with animals: Yes. I have a dog and we play

State opinions: All the time, not afraid to speak on how I feel

Ask opinions: Very often

What is your ultimate career goal? I would love to do anything that has to do with music. I love to sing.

What kind of pressure do you feel about your future? My mom puts a lot of pressure on me because I procrastinate too much. My brother also puts some pressure on me because he doesn't want me to make the same mistakes he made.

What artistic talents do you have (music, art, dance, performance, film/video making, writing, etc.)? How skilled are you? I sing, dance, and write poetry.

What about you will make an interesting room-mate? My unique personality makes it easy for others to get along with me and enjoy my company. I enjoy doing a variety of things and in no way am I closed-minded.

How would someone who really knows you describe your best traits? I'm funny, spontaneous, honest, a good listener, sincere, intelligent, outspoken, kind. I'm real when it comes to interacting with other people. I say what's on my mind and welcome their opinion, as well.

How would someone who really knows you describe your worst traits? Talk too much, smoke, curse too much.

Do you have a boyfriend or girlfriend? How long have you been together? Where do you see the relationship going? I am seeing a girl right now. I am totally in love with her. We were friends for eight months before we actually came out about our feelings.

What qualities do you seek in a mate? Honesty, sincerity, sensitivity, good sense of humor, confident, outgoing, intelligent, and goal-oriented.

How important is sex to you? Do you have it only when you're in a relationship or do you seek it out at other times? Sex is only important to me when I love the person. I must admit, I do have sex when I am not in a relationship.

interacting with other people.

Confide in your parents: Most of the time

Volunteer: Sometimes

Procrastinate: Often

Eat: Often

Get drunk: Never

Diet: Never

Vote: Not registered

Cry: Often

Laugh: All the time

Instigate: Not really

Cinema: Not really

Theater: When I can

Concerts: Yes

Clubs: All the time

Parties: All the time

Surf the Web: All the time

Aneesa: I'm 19 but I still feel young. I feel like I'm at the point that I need to take control of something. I'm not going to be living with my mom forever, even though I think she wants me to. I feel immature a lot. In school I get really bored and feel unfocused and will mess around in the back of the classroom. It's weird, though, 'cause I feel young but I can't stand people who are younger than me. I can't stand how they act. Grow up and call me back.

Describe your fantasy date: To go somewhere warm, have dinner, go dancing, and make love somewhere that we can hear the ocean.

What do you do for fun? I like to go out and be around a lot of people. I love to go to clubs and meet new people or just sit at home with good friends and laugh the whole night.

What are your favorite musical groups/artists? Jill Scott, The Roots, Björk, Tori Amos, Ani DiFranco, Mos Def, Outkast, Mary J. Blige, Guru, Nas, Tracy Chapman.

Describe a typical Friday or Saturday night: I get dressed around 11 PM, go pick up my friend, get to the club and stay until 2 AM, go to the after-hours club until 4:00 AM, then drive my a** home to bed.

Other than your girlfriend or boyfriend, who is the most important person in your life right now? My mother. She is my best friend. Even though we fight, we have a great bond. She would and has done anything and everything to make me happy.

What are some ways you have treated someone who has been important to you that you are proud of? I treat all the people who are important to me with equal respect. In all relationships you get in fights and hurtful things are said. I always try to show love to my friends.

I always try to

What are some ways you have treated someone who has been important to you that you are embarrassed by, or wish you hadn't done? I wish that I hadn't yelled at my mom the way I have. Also, I wish I wasn't so ungrateful toward her.

Describe your mother: I would split her into "the nice mom" and "the annoying mom." The "nice mom" speaks for itself. The "annoying mom" is always on your a** for something. Always telling you what to do and when to do it.

Describe your father: I would split his personality into "angry dad" and "funny dad."

If you have any brothers or sisters, are you close? How would you describe your relationship with them? I am very close with my brother despite the eight-year gap. He's loving. We fight sometimes over stupid crap. But besides that there aren't many conflicts.

What is the most important issue or problem facing you today? My most important issue is music. I'm in a group right now and we perform all over Philly.

Do you believe in God? Are you religious or spiritual? I do believe in God. I don't attend any formal religious services.

My mom is Jewish and my father is Muslim. I'm just spiritual.

What are your thoughts on people who have a different sexual orientation from you? I have no issues with straight people. I love people for who they are.

Do you have habits we should know about? Only smoking cigarettes.

What bothers you most about other people? I don't like people who are ignorant. I hate fake people who have to put on a front just so others will like them.

How do you handle conflicts? Do you feel that this approach is effective? In a conflict I like to talk things out. There is no reason to fight. Usually conflicts are caused by dumb things anyway.

If you could change one thing about how you look, what would that be? That my head was smaller and my hair was longer.

If you could change one thing about your personality, what would that be? I would like to not tell my business to everyone. I easily open up to people.

If you had Aladdin's lamp and three wishes, what would they be? 1) To live in a warm place 2) To be a singer 3) To keep my family safe

show love to my friends

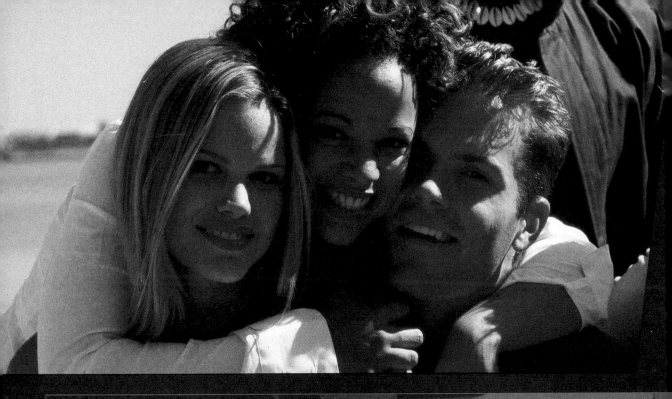

ANEESA'S FAVORITES

Cocktail: Well, I don't drink.

Breakfast: Bagel

Fast-food item: Fries

Cuisine: Japanese

Scent: Contradiction, or Eternity...I'm an old-school type of girl

Car: Any Jeep

Brand of clothing: Diesel, D&G, or anything from a thrift store

Item of clothing: Jeans

Accessory: Belt

Sneakers: A tie between Pumas and New Balances

Magazine: *The Fader*

Book: *The Coldest Winter Ever*

Movie: *Labyrinth*

Television show: *Martin*

Hour of the day: 11 PM

Song to do karaoke to: I dunno

Actor: Al Pacino

Actress: Angelina Jolie

Cartoon character: Thundercats

Sports team: Sixers

First date: To a concert

Outfit to sleep in: Boxers and a T-shirt

Video game: Don't have one

In The House

Who was the...

Best dressed: Cara and myself...we had our own unique style

Worst dressed: Tonya. We helped her out a bit, but she loved that Walla Walla fashion

Best dancer: Theo and myself. We just became one with the music

Worst dancer: Kyle and Chris. There's no hope

Best cook: Keri

Worst cook: That would have to be a tie between Tonya and me. We could make some damn good Oodles of Noodles, though

Why Aneesa Was Cast

Anthony Dominici: In a way, Aneesa's unique to *The Real World*. She's 19 and very advanced—both in terms of sexuality and personality. But at the same time, she's still really a kid who's very dependent. She's on the edge, and that's an interesting place to be.

Kenny Hull: Aneesa walked up to the casting table with bright blazing fire-red hair, and blew us all away. She interrupted everyone, got in our faces, and then stormed off. I had to run after her with an application. She was a shoo-in if there ever was one. We talked about everything—coming out to her mother, being Jewish, being black. It was serious. It wasn't until the end that we realized how funny she was. She's a truly funny person, a comedienne. She reminded me of Melissa from New Orleans—attractive, funny, extremely vulgar, and so complex. The smartest people always are.

Most hygienic: Tonya. That girl cleaned her room about three times a day

Least hygienic: That would have to be my boy Kyle.

Most diligent: A tie between Kyle and Chris

Biggest procrastinator: Keri and I, we just didn't get stuff done on time

Best mannered: We all were

Worst mannered: None

Best attitude: Cara

Worst attitude: Tonya. You would wanna stay out of her way when she's not in a good mood

Best in the morning: Cara was the best. She's so cute when she wakes up

Worst in the morning: That would have to be me, Ms. Moody

Most Overused...

Item of clothing: Can't think

The phone: That thing got used and abused

Expression: Neven

Excuse for not cleaning: "It's not my mess."

Line used by someone to get into the Real World house: "I heard there is a party" or "I know someone who lives there."

Grow up and call me back.

casting

APPLICATION INSTRUCTIONS

1. Please fill out the enclosed application legibly.

2. Use dark-colored ink.

3. Answer all questions honestly and to the best of your ability.

4. Please write only on the printed side of the paper. Feel free to attach additional sheets as necessary. DO NOT e-mail the application back.

5. Attach a page to this packet with a recent photo on it.
 (Yes, another one, even if you sent one with your original tape.)

6. You must staple a copy of your driver's license to the back of the packet.

7. Application should be accompanied by your video cassette.
 For more information, contact:

 www.bunim-murray.com
 www.mtv.com

 Mail the original copy and your video cassette to:

 REAL WORLD - CASTING DEPT.
 6007 SEPULVEDA BLVD.
 VAN NUYS, CA 91411

8. Please make sure to include enough postage when you return this packet.

Thank you for your time and effort in completing this packet.

Bunim/Murray Productions, Inc.
6007 Sepulveda Blvd.
Van Nuys, CA 91411
Casting info: http://www.bunim-murray.com

THE REAL WORLD

SEASON 11 APPLICATION FORM

NAME: _____

INTRODUCTORY INFO:

PRESENT ADDRESS: _____ PHONE: _____
_____ 2nd PHONE.: _____
_____ Cell/Pgr: _____
_____ E-mail: _____
 I check my e-mail a lot: Yes ○ No ○
_____ 2nd E-mail: _____
BIRTHDATE: _____ AGE: _____
SOCIAL SECURITY NO.: _____

MOTHER'S NAME, PHONE, and ADDRESS: FATHER'S NAME, PHONE, and ADDRESS
Check here if this is your permanent address: ○ Check here if this is your permanent address: ○
_____ _____
_____ _____
_____ _____
_____ _____

SIBLINGS (names and ages): _____

WHAT IS YOUR ETHNIC BACKGROUND? _____

ARE YOU OR HAVE YOU EVER BEEN A MEMBER OF SAG/AFTRA? HAVE YOU EVER ACTED OR
PERFORMED OUTSIDE OF SCHOOL? _____

EDUCATION:

NAME OF HIGH SCHOOL (and years completed):

NAME OF COLLEGE (years completed and majors):

OTHER EDUCATION:

WHERE DO YOU WORK? DESCRIBE YOUR JOB HISTORY:

WHAT IS YOUR ULTIMATE CAREER GOAL?

WHAT KIND OF PRESSURE DO YOU FEEL ABOUT MAKING DECISIONS ABOUT YOUR FUTURE? WHO'S PUTTING THAT PRESSURE ON YOU?

WHAT ARTISTIC TALENTS DO YOU HAVE (MUSIC, ART, DANCE, PERFORMANCE, FILM/VIDEO MAKING, WRITING, ETC.)? HOW SKILLED ARE YOU?

WHAT ABOUT YOU WILL MAKE YOU AN INTERESTING ROOMMATE?

IF YOU'RE LIVING WITH A ROOMMATE, HOW DID YOU HOOK UP WITH HIM OR HER? TELL US ABOUT HIM OR HER AS A PERSON. DO YOU GET ALONG? WHAT'S THE BEST PART ABOUT LIVING WITH HIM OR HER? WHAT'S THE HARDEST PART ABOUT IT?

HOW WOULD SOMEONE WHO REALLY KNOWS YOU DESCRIBE YOUR BEST TRAITS?

HOW WOULD SOMEONE WHO REALLY KNOWS YOU DESCRIBE YOUR WORST TRAITS?

DESCRIBE YOUR MOST EMBARRASSING MOMENT IN LIFE:

DO YOU HAVE A BOYFRIEND OR GIRLFRIEND? HOW LONG HAVE YOU BEEN TOGETHER? WHERE DO YOU SEE THE RELATIONSHIP GOING? WHAT DRIVES YOU CRAZY ABOUT THE OTHER PERSON? WHAT'S THE BEST THING ABOUT THE OTHER PERSON?

WHAT QUALITIES DO YOU SEEK IN A MATE?

HOW IMPORTANT IS SEX TO YOU? DO YOU HAVE IT ONLY WHEN YOU'RE IN A RELATIONSHIP OR DO YOU SEEK IT OUT AT OTHER TIMES? HOW DID IT COME ABOUT ON THE LAST OCCASION?

DESCRIBE YOUR FANTASY DATE:

WHAT DO YOU DO FOR FUN?

DO YOU PLAY ANY SPORTS? DESCRIBE YOUR ATHLETIC ABILITY:

WHAT ARE YOUR FAVORITE MUSICAL GROUPS/ARTISTS?

DESCRIBE A TYPICAL FRIDAY OR SATURDAY NIGHT:

WHAT WAS THE LAST UNUSUAL, EXCITING, OR SPONTANEOUS OUTING YOU INSTIGATED FOR YOU AND YOUR FRIENDS?

DO YOU LIKE TRAVELING? DESCRIBE ONE OR TWO OF THE BEST OR WORST TRIPS YOU HAVE TAKEN. WHERE WOULD YOU MOST LIKE TO TRAVEL?

OTHER THAN A BOYFRIEND OR GIRLFRIEND, WHO IS THE MOST IMPORTANT PERSON IN YOUR LIFE RIGHT NOW? TELL US ABOUT HIM OR HER:

WHAT ARE SOME WAYS YOU HAVE TREATED SOMEONE WHO HAS BEEN IMPORTANT TO YOU THAT YOU ARE PROUD OF?

WHAT ARE SOME OF THE WAYS YOU HAVE TREATED SOMEONE WHO HAS BEEN IMPORTANT TO YOU THAT YOU ARE EMBARRASSED BY, OR WISH YOU HADN'T DONE?

IF YOU HAD TO DESCRIBE YOUR MOTHER, (OR YOUR STEPMOTHER, IF YOU LIVED WITH HER MOST OF YOUR LIFE AS A CHILD), BY DIVIDING HER PERSONALITY INTO TWO PARTS, HOW WOULD YOU DESCRIBE EACH PART?

IF YOU HAD TO DESCRIBE YOUR FATHER, (OR YOUR STEPFATHER), BY DIVIDING HIS PERSONALITY INTO TWO PARTS, HOW WOULD YOU DESCRIBE EACH PART?

HOW DID YOUR PARENTS TREAT EACH OTHER? (Did your parents have a good marriage? What was it like?)

DESCRIBE HOW CONFLICTS WERE HANDLED AT HOME AS YOU WERE GROWING UP (Who would win and who would lose, whether there was yelling or hitting, etc.):

IF YOU HAVE ANY BROTHERS OR SISTERS, ARE YOU CLOSE? HOW WOULD YOU DESCRIBE YOUR RELATIONSHIP WITH THEM? _____

DESCRIBE A MAJOR EVENT OR ISSUE THAT'S AFFECTED YOUR FAMILY: _____

DESCRIBE A QUALITY/TRAIT THAT RUNS IN YOUR FAMILY: _____

WHAT IS THE MOST IMPORTANT ISSUE OR PROBLEM FACING YOU TODAY? _____

IS THERE ANY ISSUE, POLITICAL OR SOCIAL, THAT YOU'RE PASSIONATE ABOUT? HAVE YOU DONE ANYTHING ABOUT IT? _____

WHO ARE YOUR HEROES AND WHY? _____

DO YOU BELIEVE IN GOD? ARE YOU RELIGIOUS OR SPIRITUAL? DO YOU ATTEND ANY FORMAL RELIGIOUS SERVICES? _____

WHAT ARE YOUR THOUGHTS ON: ABORTION? _____

PEOPLE WHO HAVE A DIFFERENT SEXUAL ORIENTATION FROM YOU? _____

GUN CONTROL? _____

AFFIRMATIVE ACTION? _____

DO YOU HAVE ANY HABITS WE SHOULD KNOW ABOUT? _____

DO YOU: SMOKE CIGARETTES? CIRCLE (YES/NO) _____

DRINK ALCOHOL? (YES/NO) IF YES, WHAT IS YOUR FAVORITE ALCOHOLIC BEVERAGE?

DO YOU SMOKE MARIJUANA OR USE HARD DRUGS? HAVE YOU EVER? PLEASE EXPLAIN:

THE REAL WORLD AND *ROAD RULES* HAVE A ZERO TOLERANCE DRUG POLICY. IF YOU USE DRUGS, CAN YOU GO WITHOUT FOR SEVERAL MONTHS?

ARE YOU ON ANY PRESCRIPTION MEDICATION? IF SO, WHAT, AND FOR HOW LONG HAVE YOU BEEN TAKING IT?

ARE YOU NOW SEEING, OR HAVE YOU EVER, SEEN A THERAPIST OR PSYCHOLOGIST? IF SO, EXPLAIN.

HAVE YOU EVER BEEN ARRESTED? (If so, what was the charge and were you convicted?)

WHAT BOTHERS YOU MOST ABOUT OTHER PEOPLE?

DESCRIBE A RECENT MAJOR ARGUMENT YOU HAD WITH SOMEONE. WHO USUALLY WINS ARGUMENTS WITH YOU? WHY?

HAVE YOU EVER HIT ANYONE IN ANGER OR SELF-DEFENSE? IF SO, TELL US ABOUT IT (How old were you, what happened, etc.):

HOW DO YOU HANDLE CONFLICTS? DO YOU FEEL THAT THIS APPROACH IS EFFECTIVE?

DO YOU EVER FEEL INTIMIDATED BY OTHER PEOPLE? WHY? HOW DO YOU REACT IN THESE MOMENTS?

HAVE YOU EVER INTERVENED TO STOP AN ARGUMENT OR FIGHT? IN YOUR OPINION, WHEN DOES AN ARGUMENT ESCALATE TO THE POINT WHERE IT SHOULD BE STOPPED?

IF YOU COULD CHANGE ANY ONE THING ABOUT THE WAY YOU LOOK, WHAT WOULD THAT BE?

IF YOU COULD CHANGE ANY ONE THING ABOUT YOUR PERSONALITY, WHAT WOULD THAT BE?

IF SELECTED, IS THERE ANY PERSON OR PART OF YOUR LIFE YOU WOULD PREFER NOT TO SHARE? IF SO, DESCRIBE (I.E. FAMILY, FRIENDS, BUSINESS ASSOCIATES, SOCIAL ORGANIZATIONS, OR ACTIVITIES):

IS THERE ANYONE AMONG YOUR FAMILY OR CLOSE FRIENDS WHO WOULD OBJECT TO APPEARING ON CAMERA? IF SO, WHY?

WHAT IS YOUR GREATEST FEAR AND WHY?

IF YOU HAD ALADDIN'S LAMP AND THREE WISHES, WHAT WOULD THEY BE?

PLEASE COMMENT ON YOUR PREFERENCES FOR THE FOLLOWING ACTIVITIES:

ACTIVITY:	COMMENT:
Read books	_____
Sleep 8 hours	_____
Watch television daily, which shows?	_____
Shop	_____
Go out/party	_____
Spend time with friends	_____
Spend time alone	_____
Balance work/study	_____
Talk on the phone	_____
Cook	_____
Clean	_____
Write/e-mail	_____
Read newspapers (which sections?)	_____
Play with animals	_____
State opinions	_____
Ask opinions	_____
Confide in your parents	_____
Volunteer	_____
Procrastinate	_____

Eat _____ _____

Get drunk _____ _____

Diet _____ _____

Vote _____ _____

Cry _____ _____

Laugh _____ _____

Instigate _____ _____

Cinema _____ _____

Theatre _____ _____

Concerts _____ _____

Clubs _____ _____

Parties _____ _____

Surf the web _____ _____

My favorite Web sites are: _____ _____

List 4 people who have known you for a long time and will tell us what a great person you are (excluding relatives), please include two adults and two of your friends.

NAME, ADDRESS, PHONE

1. _____

HOW DO THEY KNOW YOU? _____

2. _____

HOW DO THEY KNOW YOU? _____

3. _____

HOW DO THEY KNOW YOU? _____

4. _____

HOW DO THEY KNOW YOU? _____

Please help us get in touch with you. If you have other people (roommates, boyfriend/girlfriend, boss, relatives etc.) who frequently know where you are and how to get in touch with you, please list them below. As we cast on a short schedule, getting in touch with you quickly helps everyone.

NAME: _____ RELATION: _____ PHONE: _____

HOW FAMILIAR ARE YOU WITH *THE REAL WORLD*? _____

HOW DID YOU HEAR ABOUT OUR CASTING SEARCH? _____

I acknowledge that everything stated in this application is true. I understand that any falsely submitted answers can and will be grounds for removal from the application process and from my subsequent participation in the final series. I further acknowledge and accept that this application form and the video tape I previously submitted to MTV will become property of MTV and will not be returned. By signing below, I grant rights for MTVN/Bunim-Murray Productions (BMP) to use any biographical information contained in this application, my home video, or taped interview, and to record, use, and publicize my home video tape or taped interview, voice, actions, likeness, and appearance in any manner in connection with *THE REAL WORLD* and/or *ROAD RULES*.

SIGNATURE _____ DATE _____

Please remember to staple a photocopy of your driver's license or passport to this packet. When faxing, do not include the photocopy. Thank you for your time and effort in completing this form.